PHOTOGRAPHY BY:

CLAUDINE DOURY

RENÉ FIETZEK

OLYA IVANOVA

NATALIA KUPRIYANOVA

DMITRY LOOKIANOV

EGOR ROGALEV

VLADIMIR SHIPOTILNIKOV

MICHAL SOLARSKI

HOLIDAYS IN SOVIET SANATORIUMS

MARYAM OMIDI

FUEL

Visiting a Soviet-era sanatorium is like stepping back in time. Vestiges of another age linger all around – in fragments of decades-old wallpaper stubbornly clinging to walls, or colourful mosaics glorifying the Soviet worker. Plants of all shapes and sizes inhabit every corner, while spartan guest rooms with single beds evoke a bygone era when guests travelled to sanatoriums alone. Mealtimes too are unforgettable, with food in more shades of beige than you ever thought possible. Then, of course, there are the treatments: from crude-oil baths and radon-water douches to underground salt caves and magnetic sands, these sanatoriums offer a dizzying introduction to a whole new world of medicine.

Soviet-era sanatoriums are among the most innovative, and sometimes most ornamental, buildings of their time – from Kyrgyzstan's Aurora (page 148), designed in the shape of a ship, to Druzhba (page 116), a Constructivist masterpiece on the Crimean shore that sparked rumours that a flying saucer had landed. Such buildings challenge the standard notion that architecture under communism was unsightly and drab. Sprinkled across the post-Soviet landscape, they survive in varying states of decay, with relatively few still in operation. But at their peak, these sanatoriums were visited by millions of citizens across the USSR each year, courtesy of the state.

The issue of free time greatly engaged Soviet leaders as they set out to define and shape the New Soviet Man. Unlike western vacations, which Soviets perceived as vulgar pursuits characterised by conspicuous consumption and idleness, holidays in the USSR were decidedly purposeful. Their function was to provide rest and recuperation, so citizens could return to work with renewed diligence and productivity. The 1922 Labour Code prescribed two weeks' holiday a year for many workers and under Joseph Stalin the 'right to rest' was enshrined in the 1936 constitution for all citizens of the USSR. In line with Stalin's First and Second Five-Year Plans, writes Johanna Geisler in *The Soviet Sanatorium: Medicine, Nature and Mass Culture in Sochi, 1917–1991*, rapid development of the industry meant that by 1939, 1,828 new sanatoriums with 239,000 beds had been built.

It was against this backdrop that the sanatorium holiday was born. A cross between medical institution and spa, the sanatorium formed an integral part of the Soviet political and social apparatus. They were designed in opposition to the decadence of European spa towns such as Baden-Baden or Karlovy Vary, as well as to the west's bourgeois consumer practices. Every detail of sanatorium life, from architecture to entertainment, was

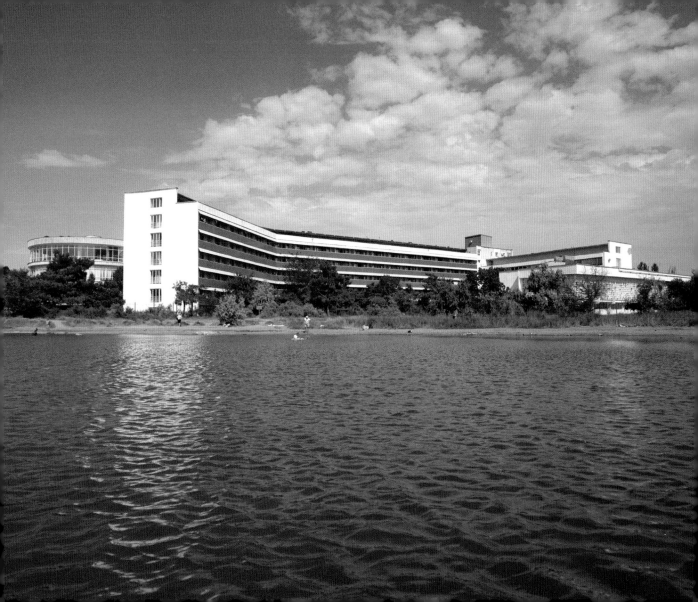

intended to edify workers while encouraging communion with other guests and with nature. The approach was straightforward, advocating maximum rest, evidenced by the addition of a few extra pounds on departure, which was considered a sign of robust health. This was believed to deliver maximum post-sanatorium productivity, a notion that has persisted to this day. Writing in *Club Red: Vacation Travel and the Soviet Dream*, Diane Koenker notes that the Soviets were proud of their progressive treatment of workers; the French, wrote Health Commissar Nikolai Semashko in 1923, had only one place of rest: the cemetery.

Eligible individuals received *putevki*, or vouchers, to stay at particular sanatoriums for a specified period of time, either at subsidised rates or for free. In principle, industrial workers and those with medical conditions were granted priority, though in practice, the best accommodation usually went to those with money and connections. To varying degrees, the voucher system still exists across the post-Soviet sphere, with both governments and corporations providing *putevki* to individuals for subsidised sanatorium visits. While most Georgian sanatoriums are for fee-paying guests, those in Belarus accept a high proportion of guests with *putevki* as part of the Belarusian government's social support fund.

Soviet holidaymakers would start with a visit to the resident doctor, who would draw up a tailor-made programme of callisthenics, dietary recommendations and treatments. Traditional therapies such as mineral-water baths were offered alongside more innovative treatments such as electrotherapy. Some sanatoriums provided regional treatments such as grape therapy in Crimea or *kumis* (mare's milk) in Central Asia, which is still offered at Jeti-Ögüz sanatorium in Kyrgyzstan today.

Gradually, a shift towards a more relaxed sanatorium culture developed and today guests can undertake as many treatments as they wish and come and go as they please. But in the early days of the Soviet Union, every aspect of sanatorium life, from sleep to sunbathing, was controlled and monitored by staff in accordance with a strict schedule. 'Patients were prohibited from making noise, stamping feet, slamming doors and shouting... drinking spirits and gambling were also not allowed, nor was spitting on the floor,' writes Geisler. When it was eventually permitted in the 1930s, entertainment came in the form of lectures on atomic energy and theatrical performances intended to enlighten rather than simply amuse. Olga Kazakova, director of the Institute of Modernism in Moscow, recalls how her parents were often less than enthusiastic about visiting sanatoriums. '[The] life of a Soviet citizen was regulated in so many ways and they did not want to live according to a timetable that expected them to march to the canteen with all the others. Moreover, since these holiday packages were distributed through work, chances were you would meet your colleagues at a sanatorium, something my parents were not so happy about.'

Food was viewed as a crucial component of health and was a carefully regulated element of any visit. Aside from those on special regimes (such as Diet No. 5 for liver disease, Diet No. 8 for obesity and Diet No. 9 for diabetes), the norm was a daily intake of around 5,000 calories – two-and-a-half times the current recommended figure for women. Today sanatoriums claim that each menu is nutritionally balanced and that calories are counted in line with recommended allowances, but the meals, often offered in all-you-can-eat buffet style, tell a different story. Dull and monotonous staples such as potatoes, cabbage, beetroot and buckwheat are served fried or drowning in mayonnaise, a throwback to the Soviet era, when the dressing was used in large quantities to disguise poor-quality food.

Alongside the rise of sanatoriums, 'kurortology' – a medical science studying the effects of nature and the elements on humans – was born. Like the Romantic poets before them, Soviet kurortologists viewed reconnection with the natural environment, previously seen as hostile and inhospitable, as having the potential both to heal illness and to end social alienation. Institutes devoted entirely to the study of kurortology were established. Investigating the efficacy of natural cures, they explored the success of treatments ranging from mud baths to light therapy. Not only did kurortology underpin medical culture in sanatoriums, but it also influenced their architecture.

A commitment to embracing the natural environment informed the works of a circle of architects that included Moisei Ginzburg, best known for the Narkomfin Building, a Constructivist housing block in Moscow. Reflecting this turn to nature, one of the most popular designs to emerge was the 'terraced sanatorium'. By blending buildings discreetly into the surrounding landscape without disrupting their integrity, such schemes emphasised harmony with nature. Two examples are Rodina in Crimea (page 60) and Metallurg in Sochi (page 144), both containing a series of different levels that seem to tumble down into the sea. In *The Architecture of Crimea*, S. K. Kilesso praises terraced designs, which he contends have a soothing effect on urban dwellers, providing them with 'the opportunity to feel as if [they're] in nature'. A stay at a sanatorium allowed guests to escape the daily grind of the city, recuperating in a space that encouraged reflection on socialist ideals. In addition, says Kazakova, ordinary citizens were afforded 'a rare chance to travel outside their own region, to experience a different climate zone and a different lifestyle'.

Although aesthetically diverse, sanatoriums were infused with the utopian values of the era, which championed architecture as a vehicle for social reform. Sanatoriums were more than just rest homes – they were social condensers, designed to foster individual growth within a communal environment. Art critic and philosopher Boris Groys has described Stalinist architecture as

'ideology, constructed', a phrase that can be extended to the entire sanatorium enterprise. Beginning with Constructivism – the Soviet Union's own brand of avant-garde modernism in the 1920s – each sanatorium captured the architectural *style du jour*. Next came Stalin's Empire Style of the 1930s, before a shift back to modernism in the late 1950s and beyond.

The 1930s – the decade in which Stalin executed millions in the Great Terror – represent a golden era of sanatorium construction. Each new example was designed to showcase the Soviet Union's progressive approach to health and leisure, and to articulate its ascendency over the west. Stalin believed that neo-classical architecture, complete with columns, cornices and chandeliers, best conveyed the message. Khrushchev, by contrast, favoured size and quantity. His denunciation of the architectural 'excesses' of his predecessor paved the way for the construction of giant sanatorium complexes in the late 1950s and 1960s. Modelled on resorts in Bulgaria and Romania, these new sanatoriums were designed for the masses and increasingly for family rather than solo visits, a change that brought an end to the traditional 'sanatorium love affair' (Diane Koenker, *Club Red: Vacation Travel and the Soviet Dream*).

According to Kazakova, sanatorium architects were afforded greater freedom in their designs. One reason was that the buildings were intended to astonish, encouraging a 'less traditional approach, which helped in gaining permission for unconventional projects'. Another was that they were often constructed on difficult terrain, as with Druzhba in Crimea, which juts out from a steep rock face. Kazakova also points out that the building of sanatoriums 'was often financed by trade unions, which were very wealthy organisations. Once you had their permission for your project, you could bypass all other agencies, which helped push the boundaries and go beyond the [usual] standards.' Even at a time when resources were strictly controlled, expensive materials such as marble were used within sanatoriums: 'Lamps and giant chandeliers made of bronze and crystal, still stagger the mind today.'

Scores of sanatoriums were destroyed during the Second World War and those that survived were used to treat the sick and wounded. It was not until the 1950s that the buildings began to be repaired and the sanatorium holiday became part of life once again. The withering of the Soviet Union in 1991 sounded the death knell for the industry, leaving many sanatoriums boarded up and abandoned. Prohibitive maintenance costs coupled with lack of interest in architectural conservation in much of the post-Soviet sphere have done little to change this situation. A number of the sanatoriums still in operation have fallen into disrepair, while others face an uncertain future. Alex Bykov, a Ukrainian architect and specialist in the architecture of the Soviet era, maintains that documents containing information about sanatoriums in Ukraine have largely

disappeared: 'Most people aren't interested in keeping historical archives so they are either lost or not taken care of. Here, people aren't interested in their Soviet past. They don't understand that Soviet history is part of their history. They want to forget it. They want to live in a modern Ukraine, but instead they live in a post-Soviet Ukraine.' For architectural conservation to take place, he adds, 'we need new architects who understand Soviet architecture so that they can bring new life to it.' According to Sergey Leonidovich, director of Miskhor sanatorium in Crimea, the future of sanatoriums lies in their privatisation. 'Billions of roubles are needed to renovate them and make them operate as they should,' he says. 'There's a lot to do and a lot of money required, which can only come from private investors.'

The rise of western spa culture and the 'experience economy' with its focus on luxury and pampering have fostered a post-Soviet generation of consumers who are increasingly less interested in the medical component of a sanatorium stay. Some sanatoriums have buckled to consumer demand, incorporating treatments such as chocolate body masks and garra rufa fish pedicures alongside traditional Soviet-style therapies. In Lithuania, capitalism has triumphed, with all traces of the Soviet era scrubbed from the country's sanatoriums in favour of a more 21st-century experience. In Crimea, Odessa and Sochi, management accept that the proximity of their sanatoriums to the beach and the opportunity to combine treatments with local nightlife

are the draws for guests in search of a little salt therapy, sun and sand.

Despite these challenges, most sanatoriums have retained something of their medical heritage. Speak to any sanatorium doctor today and the word prophylactic inevitably crops up, in a nod to Soviet medicine's focus on preventative clinical work. A stay at a sanatorium is still seen as both prevention and cure, with guests seeking treatment for a wide range of illnesses from arthritis to asthma.

Not surprisingly, little is known about sanatoriums outside the post-Soviet sphere. Given the faint regard for their conservation, this book aims to introduce sanatorium culture to those to whom it is new, while highlighting the architectural gems of the Soviet era in the hope that they will be protected and restored for future generations. 'No doubt many sanatoriums deserve to be preserved as monuments of architecture but do not have that status as of now,' says Kazakova. 'But I think that more and more people no longer hate all things Soviet and are ready to see the true value of Soviet sanatorium architecture. Let's hope that their importance will be recognised before long and at least the most prominent ones will finally be renovated.'

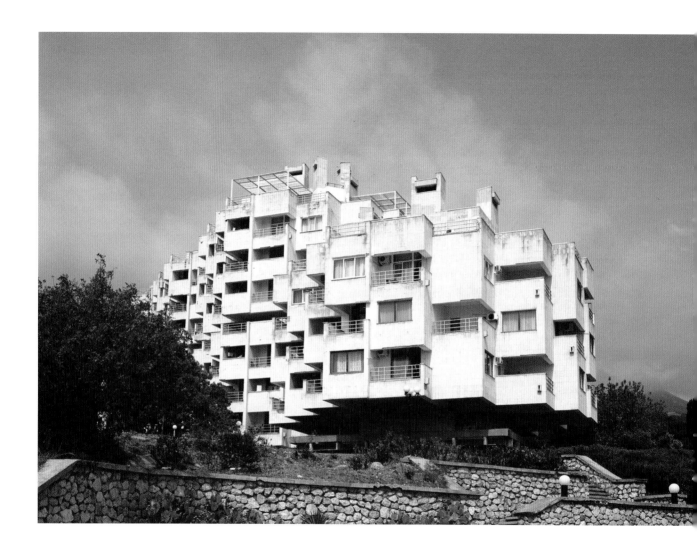

Zori Rossii Sanatorium, CRIMEA

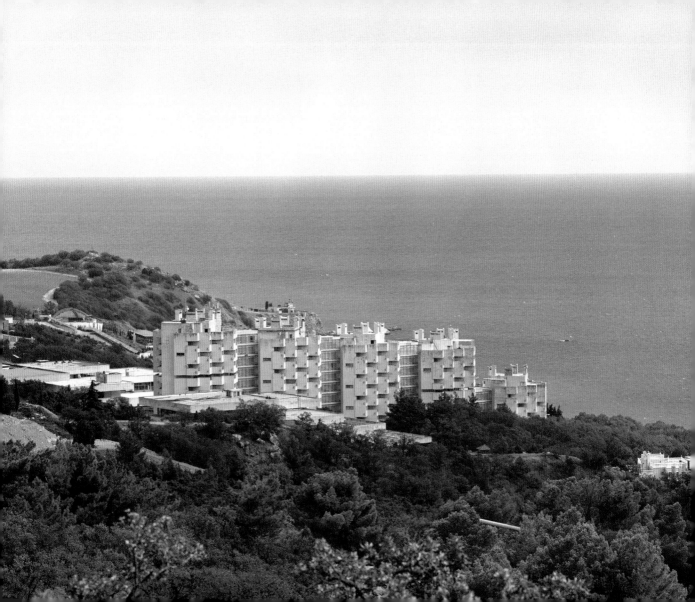

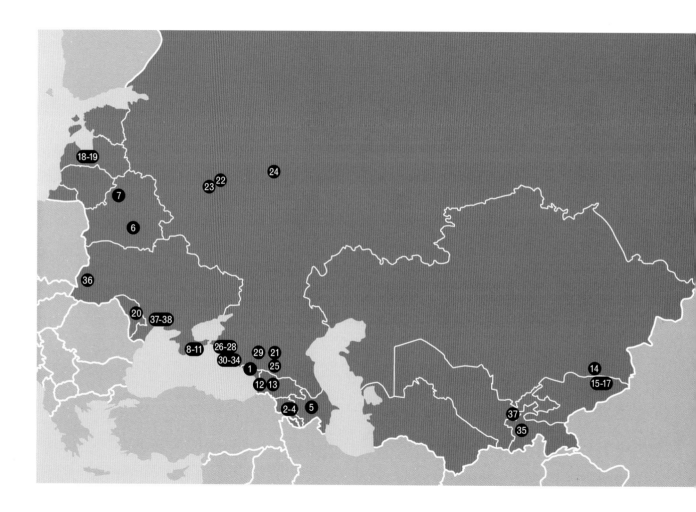

LIST OF SANATORIUMS

ABKHAZIA

AMRA INTERNATIONAL

The first thing you notice when you enter Amra sanatorium is the giant statue of Vladimir Lenin that dominates the lobby. This runs against the general trend across the post-Soviet sphere, where the vast majority of monuments to the communist revolutionary have been removed. The statue's presence speaks volumes about this neo-classical sanatorium, which perhaps more than any other is stuck in time.

Originally named The 17th Party Congress Sanatorium when it opened in 1952, Amra was built exclusively for Stalin's secret police, before it was taken over by the Communist Party Central Committee a decade later. Throughout the Soviet period, Abkhazia was a prime holiday destination for the Party elite and it was a favourite haunt of both Stalin and Khrushchev. With the disintegration of the USSR, the situation changed dramatically, and in the early 1990s Abkhazia broke away from Georgia, precipitating a civil war. Although the conflict has now abated, entry via Georgia is a convoluted process, and visitors who pass through Russia risk provoking the ire of Georgian officials.

The name Amra International is a vain attempt to lure more than just Russian tourists. This is no small ambition, given that the sanatorium barely functions: it has no doctor and offers only a handful of basic treatments, while the shabby Stalin-era interiors of the building remain largely untouched. These features (or lack of them), combined with a subtropical climate and rock-bottom prices, will satisfy any visitor's nostalgia for the USSR.

right: A stern-faced statue of Lenin surveys the scene in the reception hall of the sanatorium.

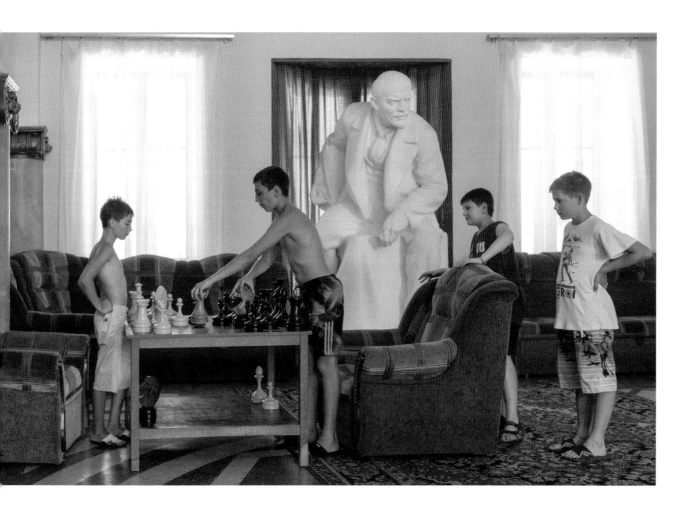

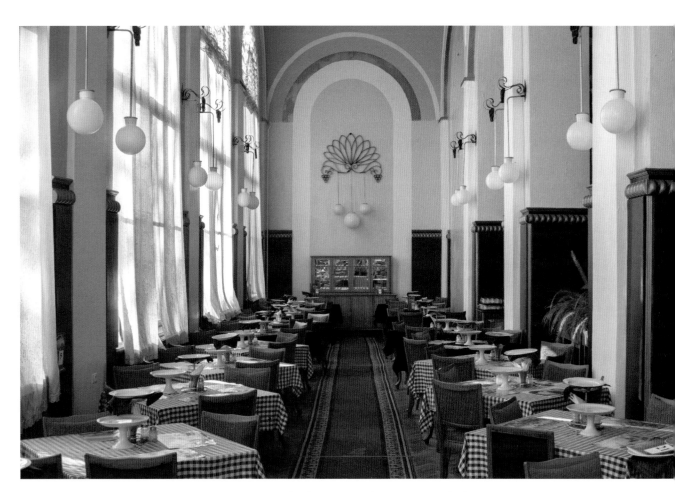

The high-ceilinged dining room recalls Soviet-era grandeur. Service at the sanatorium is desultory.

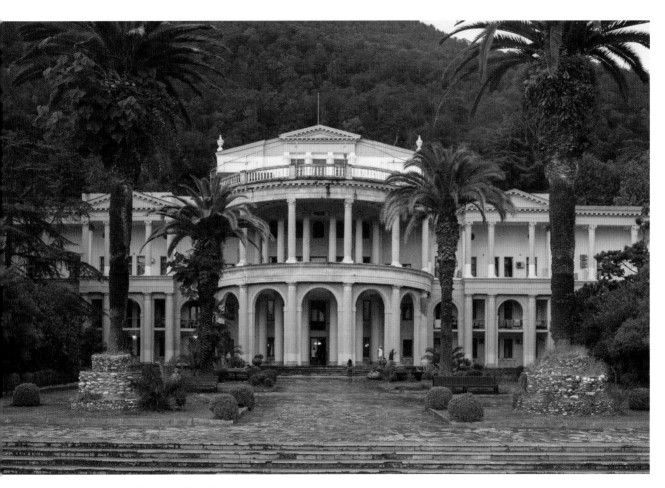

e neo-classical front entrance and subtropical gardens.

ARMENIA

JERMUK

In contrast to most of the post-Soviet sphere, sanatorium culture in the mountain spa town of Jermuk is thriving. Known as 'little Switzerland', this is a favourite destination for Armenians seeking crisp air, flower-strewn meadows and the mineral water that bubbles up from nearby springs. With a distinctive taste of salty chalk, its high alkaline content is considered curative for many ailments, especially of the digestive system. It is used in every way imaginable – from bathing to douching and of course slurping with every meal.

Daytimes are spent hopping from one treatment room to another, soaking in hot springs or touring the many medieval monasteries scattered among the nearby hills. Evenings are for promenading along the pathways that connect the seven sanatoriums, stopping every now and then at the smattering of stalls that offer fairground-style games and refreshments such as popcorn or *churchkhela*, a sweet treat of walnuts coated in grape juice.

As in most post-Soviet countries, some guests pay in full, while government employees, the disabled and the elderly are granted subsidised rates. In Armenia specifically, families who lost relatives in the Nagorno-Karabakh war with neighbouring Azerbaijan, which lasted from 1988 to 1994, are eligible for complimentary stays.

What makes Jermuk noteworthy, however, is that almost all its sanatoriums are privately owned. The result is a little more tender loving care than at those that are state run.

A number of buildings have been completely revamped, most notably Olympia (completed in 1955) and Jermuk Armenia (1964). The grey-slate constructions were designed as a hotel and polyclinic respectively, in the neo-classical style of Armenia's most celebrated architect, Alexander Tamanian (1878–1936). Both were converted into sanatoriums following private purchases at the turn of the millennium. Jermuk Armenia was bought by MP Arsen Arsenyan and Olympia by local doctor Samvel Margaryan; it is now managed by his son, Tigran.

The tendency towards family-run sanatoriums in Jermuk has ensured a level of hospitality that keeps guests returning year after year.

Ashkhar sanatorium, a long building at the northern edge of the town, was built in 1976 for government employees and has been owned by the Arakian family since 2003. Plaques around Jermuk commemorate Stepan Arakian, a local doctor and chess champion who oversaw the running of the sanatorium with his wife until he died in 2014.

An exception is the neglected Gladzor, a striking concrete block with rusting dumbbell-shaped balconies that greets visitors as they drive into Jermuk. Although the brutalist building, completed in 1986, is privately owned (by Karapet Karapetyan and his son,

who are both doctors), it is decidedly dilapidated. Perhaps because of its shabby interiors, its 500 rooms are largely empty. Soviet-nostalgia enthusiasts happy to endure a no-frills experience would be hard pressed to find a more evocative place to stay.

Most visitors prefer the swankier Olympia or Jermuk Armenia, however, and the former's success has led Tigran to start to build another sanatorium in Jermuk. His explanation for the Olympia's popularity is simple: 'The fact that it's a family business means we put a lot more heart into it.'

left: Pickled salad, once a staple of Soviet cuisine, continues to feature on the menu at Gladzor. Interiors retain Soviet-period decor.
right: The Ashkhar sanatorium (left) and Gladzor sanatorium (right) are situated in the alpine resort city of Jermuk. The pure water of the Arpa river runs through the gorge in the foreground.

previous page: A uniformed medical attendant at Ashkhar sanatorium.
Locally grown fruits. Apricots are a symbol of nationality and victory in Armenia.
The oxygen cocktail, invented in Russia in the 1960s, is said to boost metabolism and the immune system.
The girl is a guest at Olympia, one of Jermuk's more luxurious sanatoriums.

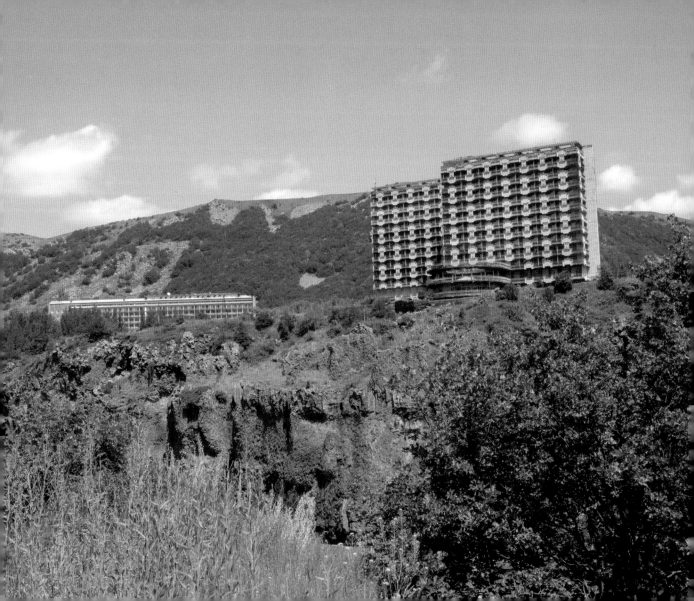

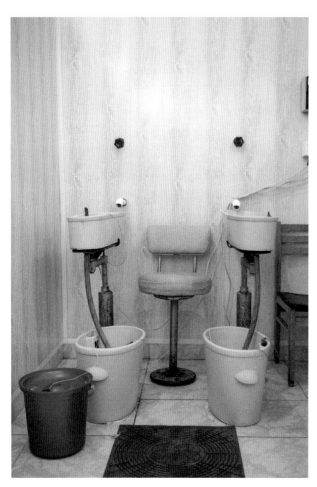

Instead of a full mineral bath, patients with heart conditions use this apparatus, allowing the submersion of arms and legs.

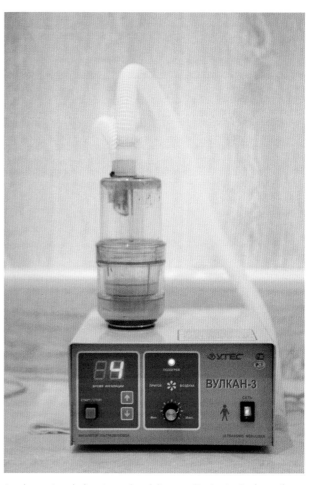

An ultrasonic nebuliser is used to deliver medication in the form of a mist, inhaled by the patient.

A cleaner at Gladzor takes a break from her work.

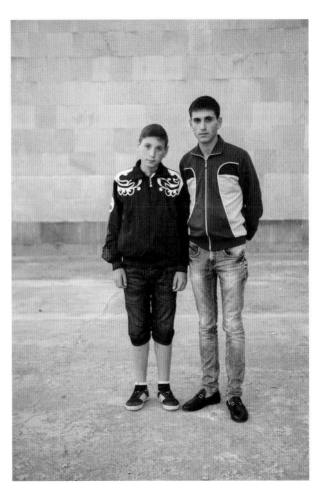

Two brothers take the mountain air in Jermuk.

With its numerous original features, Gladzor remains one of the most authentically Soviet sanatoriums in operation today. Perhaps because of this, many of its rooms lie empty, with guests preferring the luxury of nearby sanatoriums (such as Olympia) that have undergone extensive renovation.

A view of the back of the Gladzor sanatorium. The surrounding forested mountains are between 2,500 and 3,000 metres high.

AZERBAIJAN

NAFTALAN

Of all the offbeat treatments offered at sanatoriums, perhaps the most unusual is to be found at Naftalan, a city in central Azerbaijan. The arid landscape, dotted with pumpjacks, provides visitors approaching the city with a clue to the singular remedy that awaits them. Unlike most places in the world, where oil is associated with money or corruption, in Naftalan – where it is smeared liberally over the human body – it is synonymous with good health.

The most popularly prescribed treatment is a ten-minute, naked soak in a tub of silky smooth crude oil, also called naftalan, which is heated to a temperature of 38 degrees. Despite the seeming decadence of the treatment, the slipperiness of the oil, which clings like a second skin, coupled with a post-soak scrub down by an attendant using only paper towels, ensures the experience is neither graceful nor dignified. Add to this the less than sanitary conditions (barrels of oil are re-used for several months and tubs are rarely wiped down between bathers), and any notion of glamour vanishes. In addition to the brown-black oil used for bathing, a purer, transparent form of naftalan is applied to more delicate areas such as mouth and nose.

According to local legend, the oil's healing properties were discovered when a sickly camel was left for dead by traders on the Silk Road. On their return, they discovered that the dying animal had been restored to full health, a miracle they attributed to a nearby pool of black oil. Even Marco Polo noted the benefits of naftalan when he wrote in *The Travels* of 'a foundation from which oil springs in great abundance... not edible but good for burning and to treat men and animals with mange, and camels with hives and ulcers.'

right: Cupping is often used to relieve back and neck pains.
Luminotherapy (light therapy) is allegedly beneficial for a variety of skin and bone ailments.

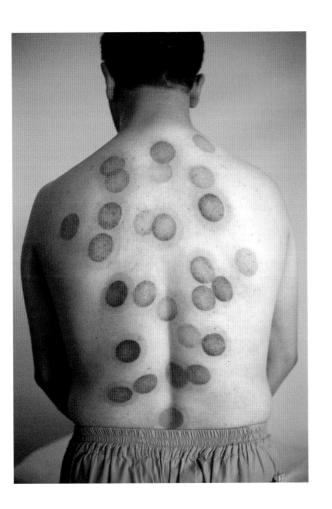
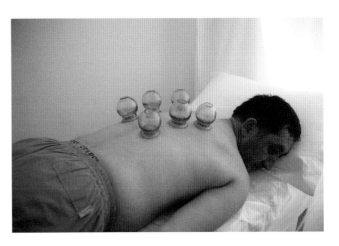
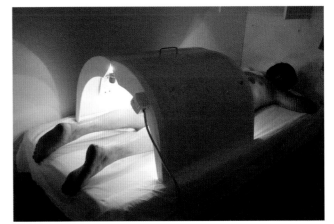

Despite stories of past cures, the use of crude oil for medicinal purposes has been condemned by western doctors as potentially carcinogenic. Naftalan oil in particular contains 50 per cent naphthalene, the hydrocarbon found in cigarette smoke, car exhaust fumes and moth-balls. Speak to any local, however, and be prepared for a panegyric on the benefits of the so-called 'miracle oil'. Although no longer open, there was once a museum filled with crutches supposedly left behind by patients who turned up at Naftalan unable to walk but departed completely cured.

One advocate is Ilgar Guseynov, the mustachioed owner of Naftalan sanatorium, whose office wall is plastered with photographs of him posing with political grandees including Ilham Aliyev, the president of Azerbaijan. Guseynov insists that the oil does no harm and lists a handful of the 80-odd illnesses naftalan allegedly cures, among them arthritis, osteochondrosis, rheumatism, infertility and a host of neurological, gynaecological and urological conditions.

The Soviets first began treating patients in the city in the 1920s and at its zenith in the 1980s Naftalan received around 70,000 visitors a year. However, a dramatic downturn occurred in 1988 when fighting broke out between Azerbaijan and Armenia in the disputed region of Nagorno-Karabakh, just a short distance away. All but one of the city's sanatoriums, Chinar, were given over to refugees from the war, who occupied the buildings for roughly two decades until they were finally rehoused as part of government efforts to resurrect Naftalan as a petroleum spa town.

The passing of time has seen Azerbaijan's Soviet sanatoriums either demolished or left to crumble, their abandoned carcasses scattered across the city. At the turn of the millennium, brand new sanatoriums began to be built , catering mainly to Azerbaijanis and Russians. Kapaz, the most recent, opened its doors in May 2016. 'There's money to be made in sanatoriums,' says Aslanova Könül Mamedali, a doctor whose family owns Kapaz, 'so even more will open.'

clockwise from top left: Masticotherapy – hot paraffin wax gradually solidifies as it cools down, providing effective treatment for inflammatory rheumatic diseases.
A nebuliser used for respiratory diseases and disorders.
Electrotherapy used to stimulate nerves and muscles.
A patient receives masticotherapy treatment to the knees.

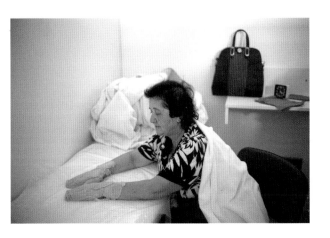
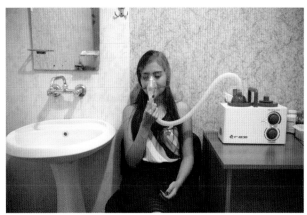
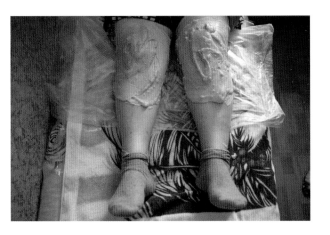
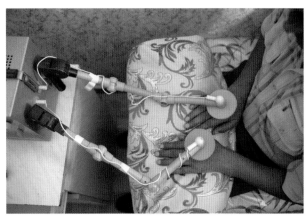

Azerbaijan is one of six Muslim post-Soviet states. Today the country stands at a cross-roads, between past and present, rural and urban. Naftalan is a city looking to the future. Of its eleven sanatoriums, only the government-owned Chinar, built in 1982, is from the Soviet era – and even that was thoroughly modernised in 2011. As with Chinar, the rest of the city's architecture leaves much to be desired, with sanatoriums falling into one of two camps: clichéd luxury spas or bland, basic accommodation. While the architecture is distinctly unmemorable, the crude-oil treatments are sure to leave a long-lasting impression.

clockwise from top left: The garden at Naftalan sanatorium. In the evenings guests relax here, drinking tea and playing chess.
The restaurant at Naftalan sanatorium serves calorie-counted meals three times a day. Watermelons help to keep guests cool on hot summer days, eaten with bread and cheese. Electrotherapy is used for a variety of conditions including anxiety, depression and insomnia.

right and page 32: Guests bathe in the silky smooth crude oil for up to ten minutes at a time before being scrubbed down by an attendant and then showering.

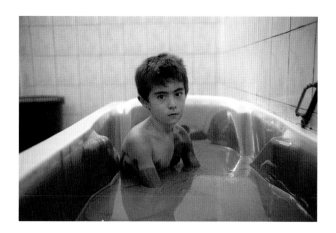

uest relaxes during a luminotherapy session.

NATIONAL SPELEOTHERAPY CLINIC

Salt therapy is offered at most sanatoriums, but the acknowledged authority for this treatment is the National Speleotherapy Clinic in the Belarusian town of Soligorsk, just south of Minsk. In contrast to the artificial salt rooms typical of sanatoriums, where guests might spend up to an hour at a time, patients at the National Speleotherapy Clinic eat, drink and sleep in a working salt mine, 420 metres underground.

Every year more than 7,000 children and adults descend to the sanatorium's salty bowels to breathe the mineral-rich air, which is reportedly both antibacterial and allergen-free – and, according to the Belarusian government, 'cleaner than in an operating theatre'. Patients stay for up to 19 days to treat skin and respiratory conditions such as asthma. The sanatorium – which opened just before the collapse of the Soviet Union – added a second building in 2012, offering above-ground facilities including a swimming pool.

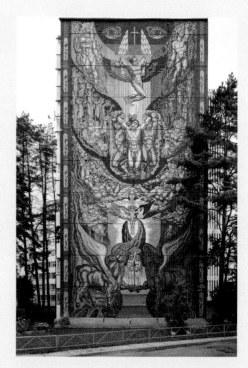

A tree of life mosaic by the Soviet artist Vladimir Krivoblotskiy symbolises the mineral-rich city of Soligorsk, a centre for salt therapy.

The main building houses both accommodation and administration for the National Speleotherapy Clinic.

National Speleotherapy Clinic, BELARUS

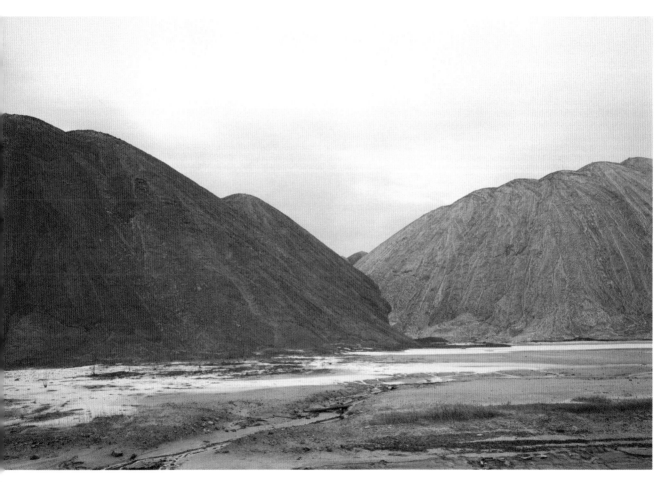

e name Soligorsk translates as 'salt mountain town', referring to the mining spoil heaps that can reach 50 to 80 metres in height.

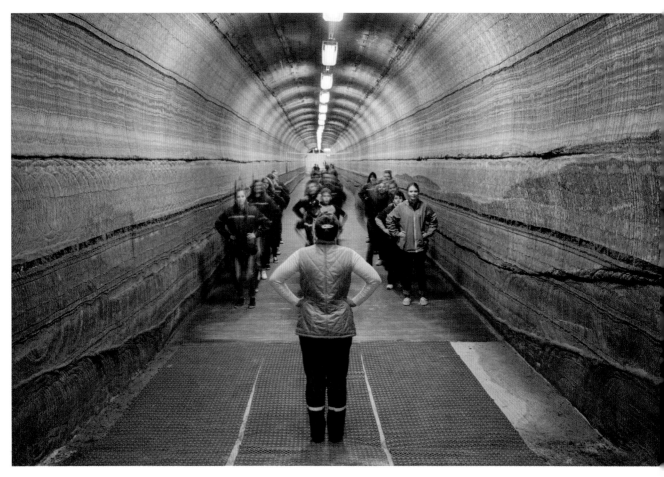

The purifying layers of sylvanite and rock salt can be seen in the walls. The tunnels contain doctors' offices and consultation rooms as well as gym apparatus and leisure areas. Curtained dormitories (right) provide sleeping areas for the guests.

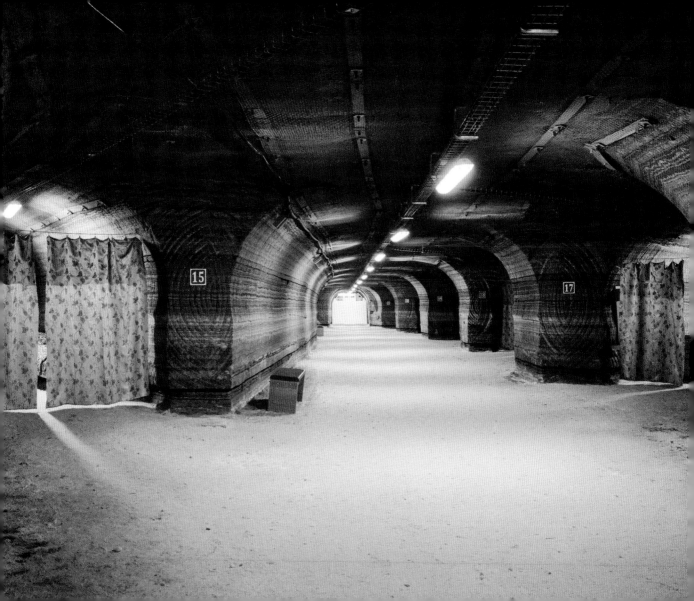

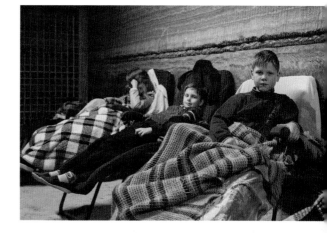

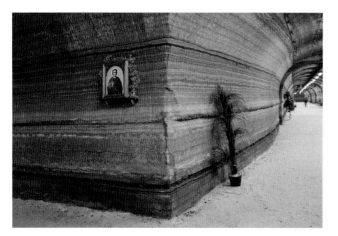

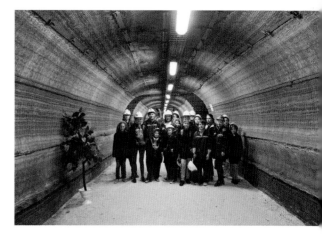

An Orthodox icon ensures the safety of all visitors to the clinic.

Young guests breathe the mine's salutary air in one of the relaxation rooms. Patients are required to wear hard hats in certain areas.

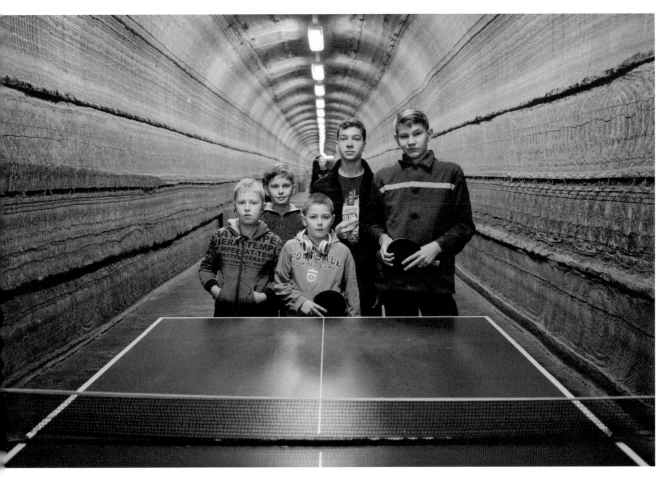

tients must be over ten years old. The air they breathe in the mine is specially moderated, containing sodium, potassium and magnesium ions. ildren are kept occupied with activities, from table tennis to billiards.

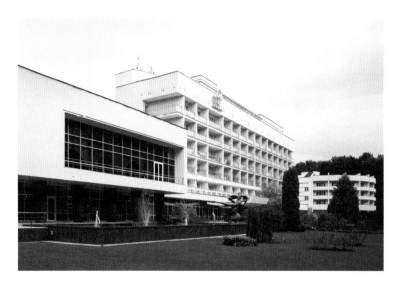

SOSNY

Arguably the most Soviet of all the former USSR territories, Belarus's charm lies in its isolation from the western world. Built in 1976, Sosny sanatorium is a perfect reflection of this, a minimalist, modernist gem nestled in the heart of Narachanski National Park. Backed by verdant forest, Sosny overlooks Lake Naroch, home to almost twenty other sanatoriums. The area is considered a national asset, both for its rich wildlife (deer, raccoons, otters and badgers) and its allegedly immune-boosting microclimate.

In addition to the usual treatments such as hydrotherapy and mud therapy, the sanatorium specialises in treating chronic fatigue syndrome and recently opened a rehabilitation centre for children with physical disabilities. In its heyday, it was visited by political dignitaries, as well as high-profile academics, actors and cosmonauts. While many Soviet-era treatments remain, the sanatorium has invested in new technology such as state-of-the-art artificial sunlamps. According to marketing manager Natalya Falevich, this allows guests to 'enjoy sunlight that is so scarce in our region'.

left: The main building at Sosny sanatorium on Lake Naroch. The name Sosny, meaning 'pines', reflects the sanatorium's location within a national park.
right: The circular section of the building houses both guest accommodation and the library.

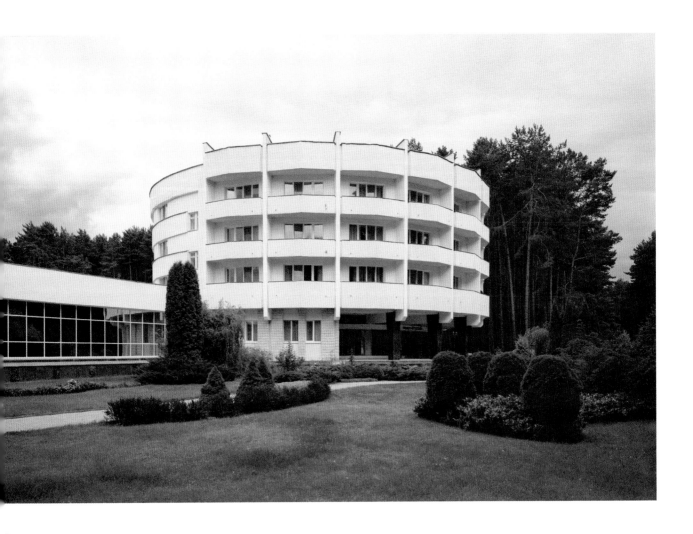

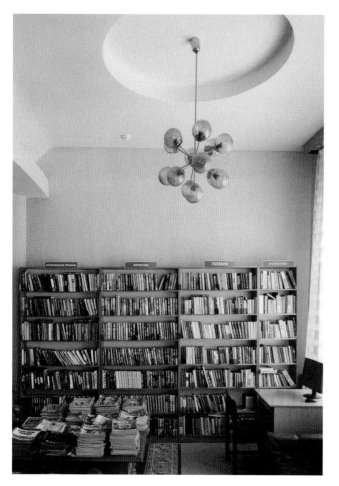

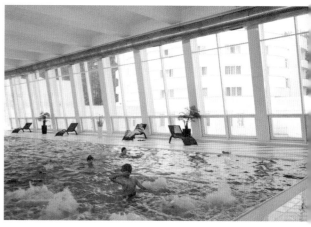

left: Many sanatoriums have libraries so that guests can cultivate their intellectual as well as physical wellbeing.
above: The large windows of the swimming pool ensure patients can swim while bathed in natural sunlight, an essential element of climate therapy.

opposite, clockwise from top left: The 'Andro-gin' machine uses light and magnetic therapies to help patients with prostate, impotence and infertility problems.
A patient undergoes spinal stretching as part of a physiotherapy regime.
Laser therapy is used to accelerate the healing process and can help with sports-related injuries or bone fractures.
Guests can choose different types of inhalation treatment, from mineral water to herbal.

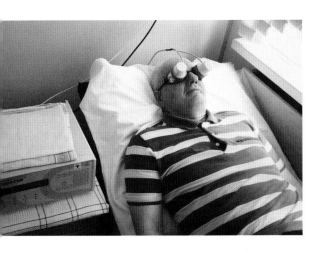
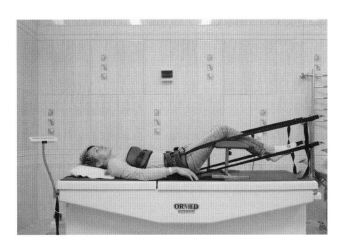
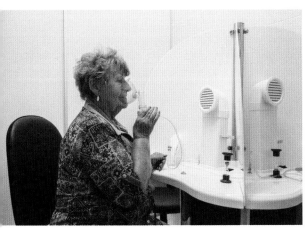
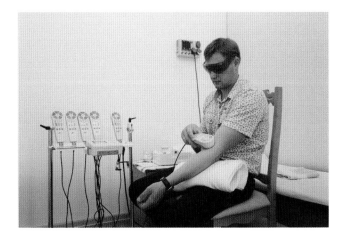

CRIMEA

With its mild climate, verdant interior and sparkling turquoise waters, Crimea has long drawn visitors to its shores. The diamond-shaped peninsula, once known as the 'jewel' of the Russian Empire, was a favourite holiday spot for Romanov tsars as well as for literary giants such as Tolstoy and Chekhov. In the 20th century, the construction of a string of unparalleled sanatoriums around Yalta – the location of the 1945 meeting where Winston Churchill, Franklin Roosevelt and Joseph Stalin carved up postwar Europe – transformed the southern coastline into one of the Soviet Union's most desirable holiday destinations.

Even today, visitors to Crimea are enchanted by its clean air and pristine waters, and climate therapy – from mud baths to seawater treatments – is still standard at most sanatoriums. Those situated along the southern shore specialise in treating respiratory diseases such as asthma and bronchitis, while those on the eastern coast offer mud-based therapies. Due to its expense, one staple no longer widely available is grape therapy, a regional and seasonal speciality that required patients to eat a daily dose of between 2 and 4 kilos of the fruit, which was said to equal mineral water in its health benefits (Diane Koenker in *Club Red*). Given its perennial balmy climate, as many guests travel to Crimea for the warm sea breezes as to recuperate at one of the many sanatoriums.

'Only 30 per cent of guests are here for treatments,' says Vladimir Borisovich, chief engineer at Parus sanatorium. 'The rest are just here to relax.'

The annexing of Crimea by Russia in March 2014, was a move that would have dramatic consequences for the peninsula's future. In the subsequent limbo, the best sanatoriums were transferred into the hands of the Russian president and access for journalists has become problematic. The Kremlin responded to the resulting slump in tourism first by tapping into the deep well of Soviet nostalgia at home, and second by exhorting Russian citizens to exercise their patriotic duty by travelling to Crimea for their next holiday. The appeal produced results: step into any Crimean sanatorium today and a large number of the guests will have made the journey from all over Russia, either independently or with *putevki* (vouchers) from their firms.

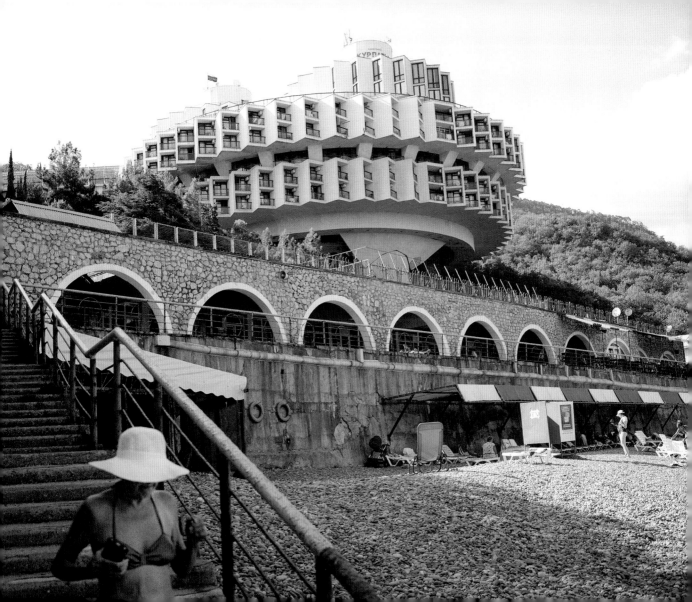

DRUZHBA

A masterpiece of craft and character, both awe-inspiring and iconic, Druzhba is the best known of all Soviet-era sanatoriums. When it was built in 1985 by architect Igor Vasilevsky and engineer Nodar Kancheli, its neo-futuristic style – it resembles a stack of concrete cogs jutting out of a steep hill – caught the eye of the Pentagon and Turkish intelligence, who mistook it for a missile-launch facility. According to Vasilevsky, others feared it might be a time-machine or a flying saucer.

Druzhba, which means 'friendship', was intended to symbolise the harmony between the Soviet Union and the former Czechoslovakia. The Soviets' All-Union Central Council of Trade Unions was pleased with the design, which seemed to resemble a ring and therefore a symbol of friendship between citizens of the two countries. Druzhba forms part of the larger Kurpaty sanatorium complex, which also includes Palmiro Togliatti, named after the former head of the Italian Communist Party. Today it is owned by the Presidential Administration of Russia.

The sanatorium's spacious guest rooms are located on the periphery of each wheel, with those most in demand overlooking the Black Sea. Constructed to operate as a social condenser, the sanatorium's lobby, library, gym, bar, canteen, theatre and swimming pool are at the core of the building. When designing Druzhba, Vasilevsky allowed nature to take precedence. Its elevation is the result of an attempt to preserve the natural landscape while fostering communion between nature and humans: 'While everything must function perfectly, the main objective of a building is still to have an emotional, aesthetic impact' (see full interview on page 188).

clockwise from top left: The 360-degree terrace at Druzhba overlooking the Black Sea.
Two concrete circles, 76 metres in diameter, contain the guest rooms. The saw-tooth design allows each one to be orientated towards the sea.
Guests during an exercise class in one of the building's curved central spaces.
A relaxation area within the building.

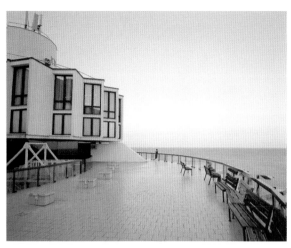

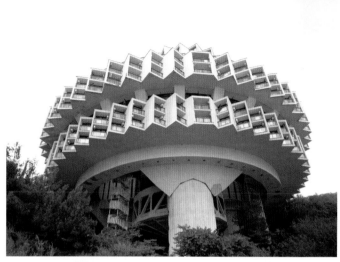

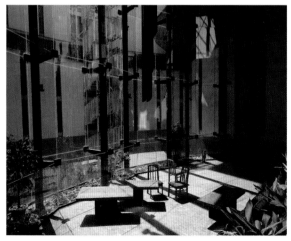

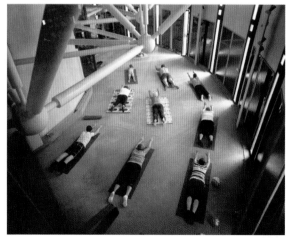

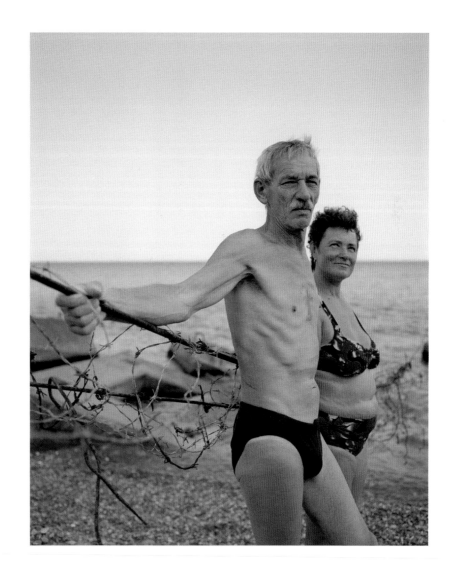

The pebble beach at Kurpaty can be reached using stairways and lifts housed in the sanatorium's concrete support columns.

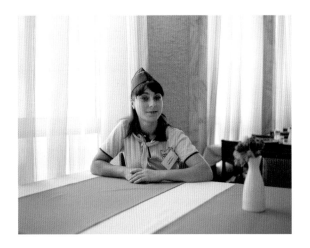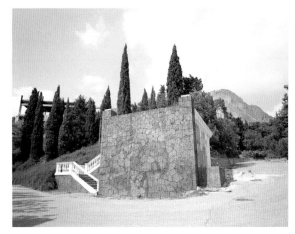

FOROS

Since opening in the early 1920s, Foros sanatorium has gone through numerous transformations. Initially treating people with a broad range of disabilities, it then focused exclusively on textile workers. After this it was allocated to children before being opened again to all patients in the 1950s. It was not until 1988, however, that it developed a distinct identity, following the construction of a striking fourteen-floor white building with balconies that snake down the façade. The construction work was carried out by military brigades stationed in Foros at the time. Just a few years later, the resort town came to international attention when Mikhail Gorbachev, the last leader of the Soviet Union, was put under house arrest while holidaying in his dacha nearby. Like many other southern Crimean sanatoriums, Foros specialises in treating respiratory diseases.

top left: A waitress in the sanatorium's canteen takes a break between meals.
above and right: The sanatorium stands close to the sea and is surrounded by a nature reserve of over 70 hectares containing more than 300 plant species.

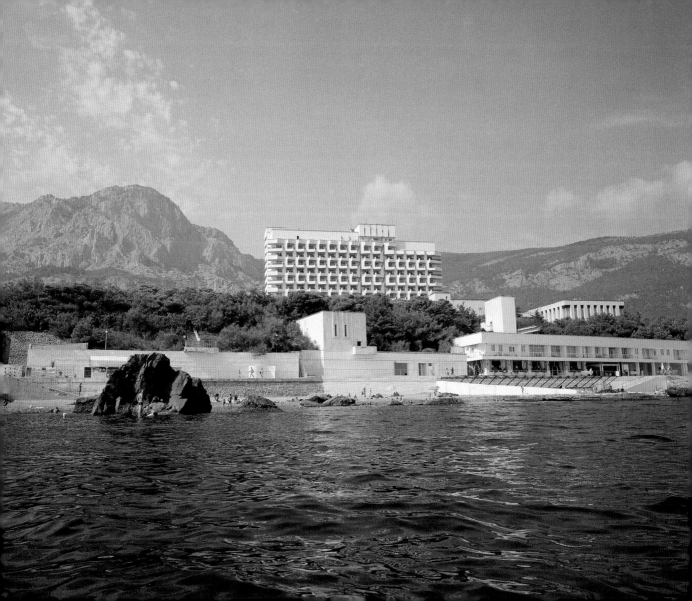

A sanatorium stay always begins with a visit to the doctor, who puts together a tailor-made programme of treatments according to the needs of each individual patient.

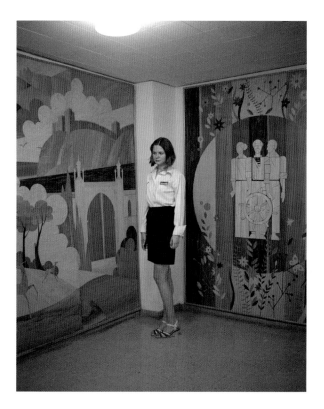

The reception area of Foros medical centre retains its Soviet-era marquetry designs.

above: The receptionist wears a uniform similar to that of a
Soviet-era Pioneer, the communist equivalent of the scouts.
top right: A monkey before a circus performance at the on-site
theatre, which can seat up to 300 guests.

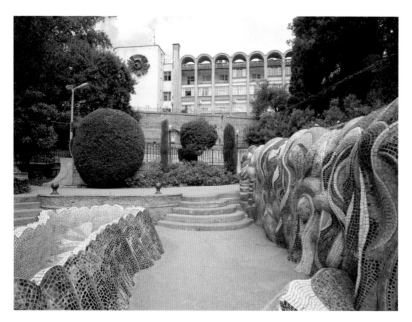

MISKHOR

Everything in the Miskhor sanatorium in southern Crimea is at a grand scale. Three imposing concrete buildings provide rooms for up to 1,152 guests. A short walk away, another building offers seven floors of treatments for all kinds of diseases. Above all, however, the allure of the brutalist sanatorium, built in 1974, lies in its location - just a short walk from the beach and set within a botanical garden.

According to sanatorium director Malikov Leonidovich, 'Nothing has changed since the 19th century, when rich Russians would come here for the microclimate.'

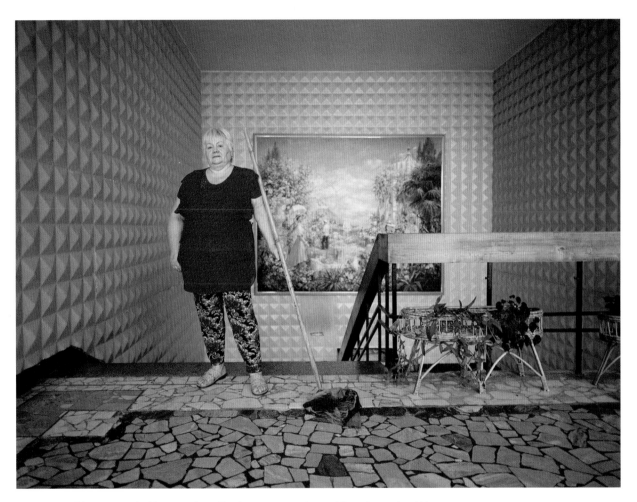

The severity of the concrete buildings is relieved by decorative mosaics outside and artworks within.

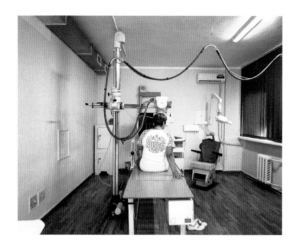

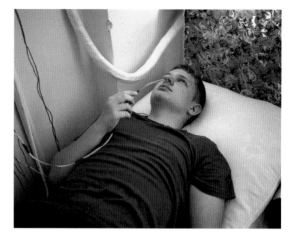

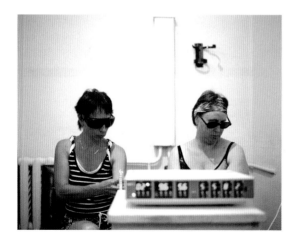

top: A Russian patient has her leg scanned by an X-ray machine.
Electrotherapy is used to treat sinusitis and other nasal inflammations.
bottom: Two women self-administer laser therapy to help reduce enlarged veins.

opposite, clockwise from top left: : A children's performance in Mishkhor's open-air theatre. In addition to providing treatments, many sanatoriums offer space for locals to stage cultural events.
Most sanatoriums offer WiFi in their common spaces, where guests can congregate in the evenings after dinner.
A guest bathes in a spa pool.
The Black Sea is just a short walk from the sanatorium. The coast is lined with sun loungers, bars and restaurants.

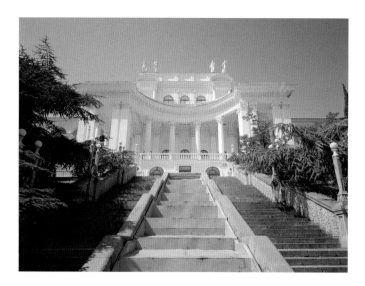

RODINA

Despite Stalin's penchant for grandiose architecture, it seems architect B. V. Efimovich may have overstepped the mark with Rodina, a sanatorium fit for Russia's Romanov dynasty. In 1955, five years after he was appointed to design the complex, Efimovich was fired from the job (it is rumoured he was sent to prison) for making Rodina too ostentatious. It is not known whether it was the broad staircase with a fountain at its centre, seemingly tumbling into the Black Sea, or the furnishings and building materials sourced from across the USSR that spelled the end for the hapless architect.

Today, the sanatorium, which is situated on the southern Crimean shore, possesses the charm of faded glory. Its name too has changed. Following the annexation of Crimea in 2014, the sanatorium formerly known as Ukraine was renamed Rodina, which means 'motherland' in Russian.

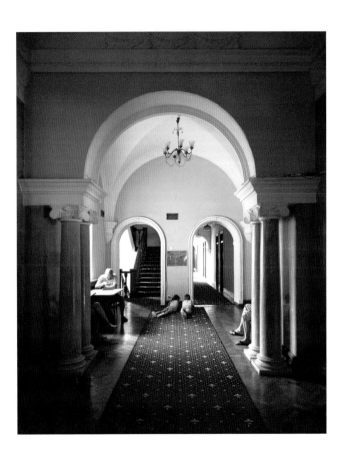

: During the Stalin era, a plethora of neo-classical sanatoriums – such as
dina, Metallurg (page 144) and Ordzhonikidze (page 148) – were built
the south coast of the Crimea.

above: Rodina's rich interiors are evocative of the period when
sanatorium culture was in its ascendancy.

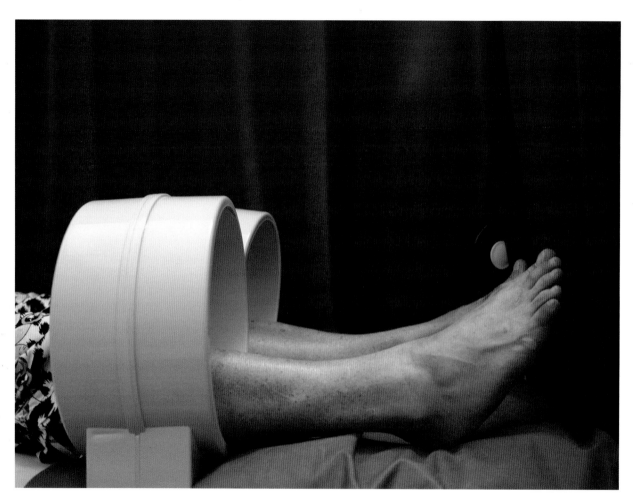

A patient receives magnetic therapy to help with leg pain.

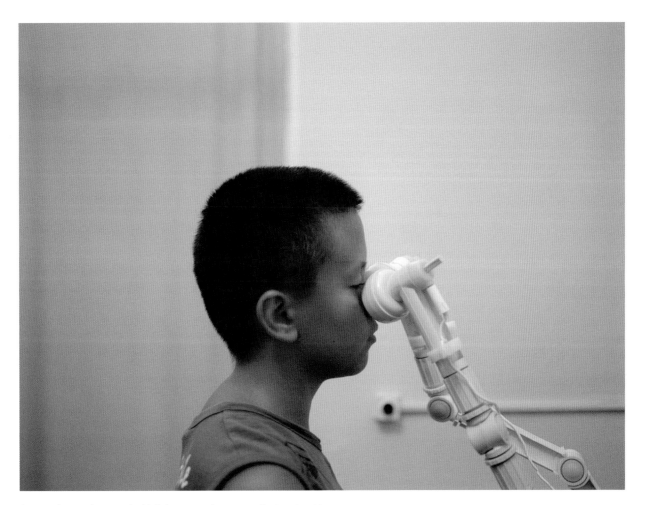

A young boy undergoes ultrahigh-frequency therapy to alleviate sinusitis.

GEORGIA

While enthusiasm for sanatorium culture continues to bloom in Armenia and Azerbaijan, in neighbouring Georgia, the industry has slumped. Although famed for its curative spring waters, crisp mountain air and Black Sea coastline, Georgia's political unrest, coupled with its citizens' disinterest in their Soviet heritage, has led to a decline in the number of both sanatoriums and guests.

During the Soviet era, the south Caucasus nation boasted some of the most sought-after holiday locations, with visitors flocking to the spa towns of Borjomi, Sairme and Tskaltubo to bathe in their legendary healing waters. The industry came crashing down in the early 1990s when, in the wake of the collapse of the Soviet Union, Georgia went to war with breakaway regions Abkhazia and Ossetia. Many of the country's sanatoriums were, and still are, used to house internally displaced persons (IDPs).

Even investment from the World Bank and the Georgian government has not succeeded in breathing new life into the industry and several sanatoriums have been sold to private companies to develop into luxury hotels. In Borjomi, source of the eponymous mineral water now bottled and sold around the world, even the 84-year-old Firuza sanatorium (one of the few survivors from the city's nine Soviet-era sanatoriums) recently conceded defeat, converting into a budget hotel in June 2016.

right: Mud treatment at the Tskaltubo Spa Resort. A plastic sheet maintains the temperature of the heated mud, which has a remedial effect on arthritis and eczema and even promotes weight loss.

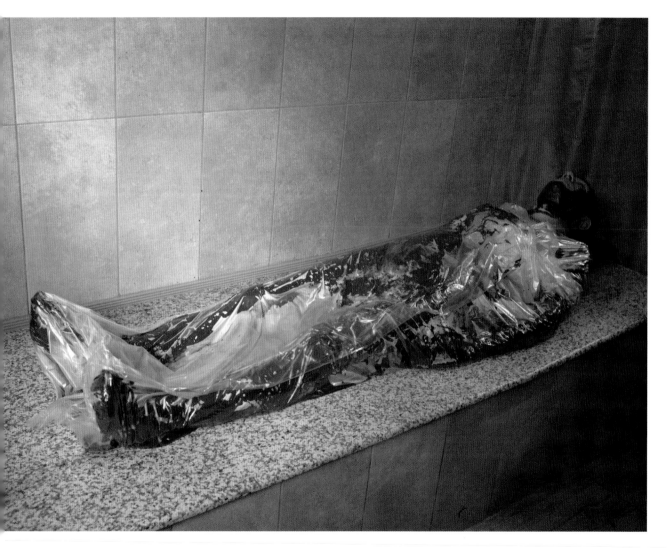

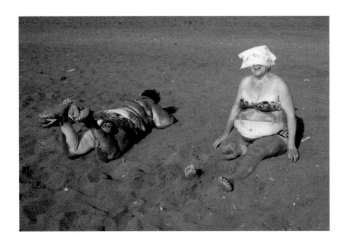

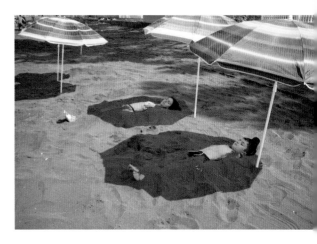

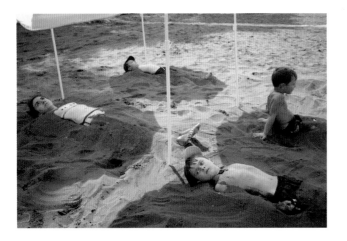

KOLKHIDA

While some sanatoriums offer mud baths or mineral-water therapies, Kolkhida's main attraction is its magnetic sand. The glittery black powder that coats the beach is believed to alleviate various ailments related to the heart, blood, joints, circulation and bones. When it opened in 1976, the sanatorium was exclusively for children and even included an on-site school for long-term patients. While children continue to be treated here, the majority of today's guests are drawn by the sanatorium's proximity to the sea – and, of course, the magnetic sand, which is free for all to use.

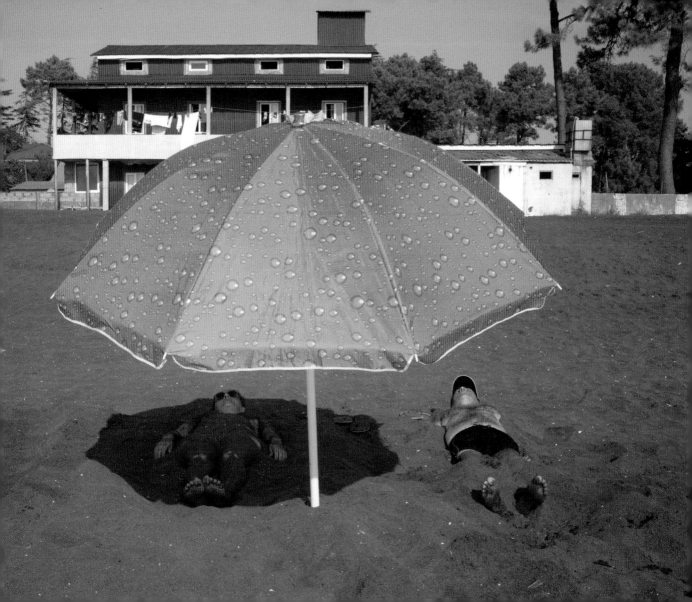

The renovated interiors of Kolkhida reflect the general trend across Georgia away from Soviet-style sanatoriums towards modern, spa-like institutions.

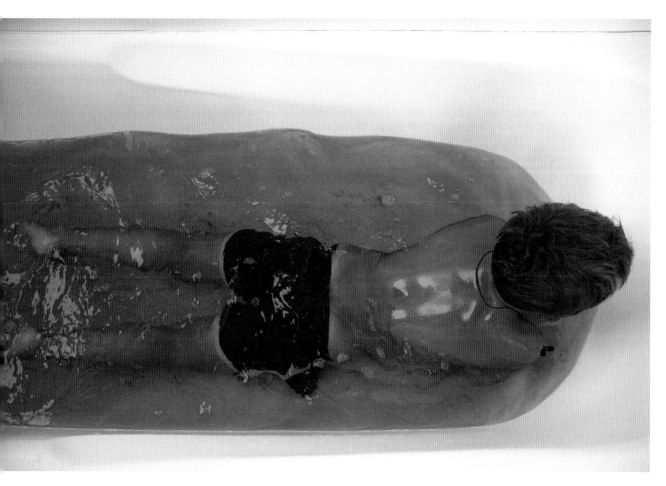

...oung patient takes a eucalyptus bath, prescribed as a remedy for respiratory problems such as asthma.

TSKALTUBO

Once a favourite destination for high-ranking Soviet officers, Tskaltubo, a spa town in west-central Georgia, is now but a shadow of its former self. Today only two of the town's 21 Soviet-era sanatoriums, almost all in an exuberant neo-classical style, are still in operation. A third is under renovation and several others have been sold for development into luxury hotels. The rest continue to provide homes to IDPs from the wars with Abkhazia and South Ossetia, their crumbling façades dotted with satellite dishes and clothes hung out to dry.

Tskaltubo's radon waters, which have long been hailed as a cure for every conceivable illness, have attracted visitors for centuries. But it was not until the 1940s that the Soviets transformed the tiny hamlet into one of the USSR's most prestigious resorts. Frequented by the Communist Party elite and linked by a special train directly to Moscow, Tskaltubo once contained eight bathhouses. Today only four remain open, offering an array of radon-water treatments including hydromassage and hydrospinal stretching. The most impressive is Bathhouse 6, built in 1950, which once contained a private treatment room for Joseph Stalin.

One of the two sanatoriums still in operation, the Tskaltubo Spa Resort was built for the navy in 1946. In the 1950s it was taken over and expanded by the Ministry of Defence. Today owner Andro Jishkariani is in the process of rebranding the building as a sanatorium-spa in order to attract a wider, fee-paying clientele. Looking for ways to diversify, he has plans to offer guests beauty and slimming packages. 'Sanatoriums are not very popular in Georgia,' he says, 'because Georgians don't care about their health unless they're dying.'

clockwise from top left: Describing itself as a 'sanatorium-spa', Tskaltubo is slowly undergoing modernisation.
A bas-relief depicting Stalin decorates the exterior of Bathhouse 6, one of a handful of bathhouses remaining from the Soviet era.
In its heyday, the now-derelict Iveria sanatorium treated the elite of Soviet society.

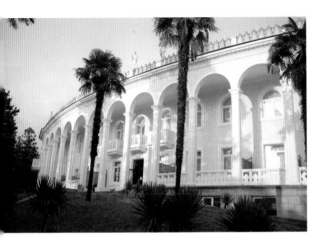

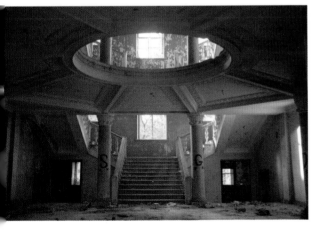
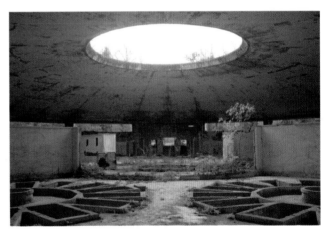

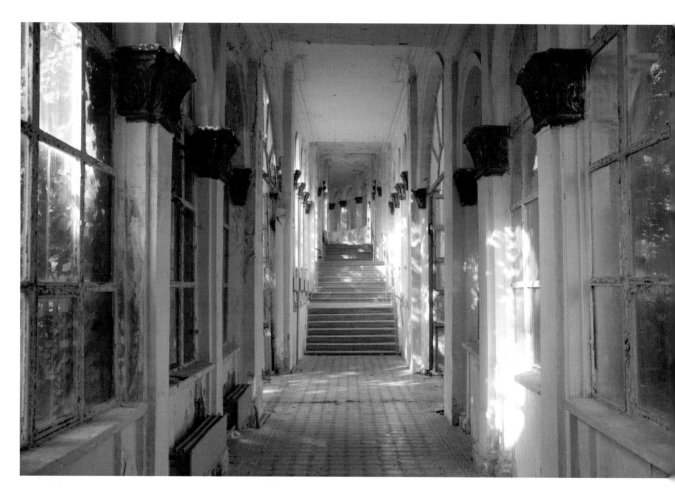

This corridor, with its crumbling walls and peeling paint, has not been renovated since Soviet times.

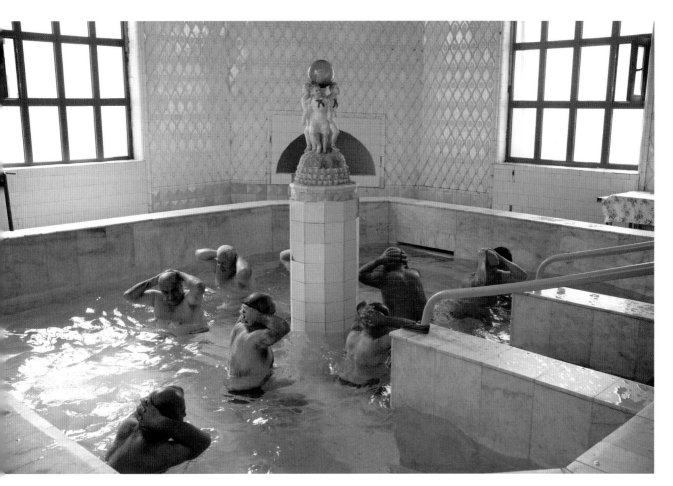

...ients exercise in mineral water at Bathhouse 6, which once included a private room for Stalin.

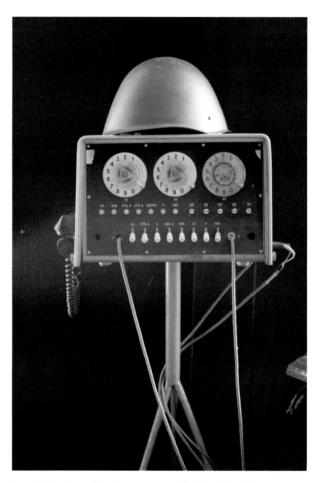

A switchboard used by military personnel visiting Tskaltubo.

Despite plans to modernise, many original features such as the rich wood panelling and lighting have been preserved.

top: The museum in Tskaltubo chronicles the history of the town, which was once home to 21 sanatoriums, many of which are now abandoned.
left: A dial-less Vertushka telephone used by high-ranking officials to receive calls directly from the Kremlin is displayed at the museum.
right: A selection of postcards offers a glimpse into the resort's more glorious past.

KAZAKHSTAN

ALATAU

Despite its vast area - about the size of western Europe - Kazakhstan did not have a significant sanatorium until the construction of Alatau in 1984. Nestling in the foothills of the Alatau mountain range, just a short ride from Almaty, Kazakhstan's largest city, the sanatorium was hailed as an architectural feat when it was built. Using the latest earthquake-proof technology, the architects were the first to erect a ten-storey building in the region. Included in the team was celebrated local architect Yuri Ratushny, best known for Almaty's iconic Palace of the Republic and Kazakhstan Hotel.

The private sanatorium zigzags through luxuriant woodlands, with a circular swimming pool on its northern side. To the west is the area's main attraction: Tuzkol Lake, dubbed the 'Dead Sea of Kazakhstan' because of its high salinity. Guests travel from across Kazakhstan to float in the still waters of the Tuzkol and smear themselves with its mud, which reportedly alleviates a wide range of chronic conditions including arthritis and hypertension.

right: The water park in the sanatorium grounds. The complex, which also has a sports centre, golf course and cinema, receives 10,000 visitors a year.

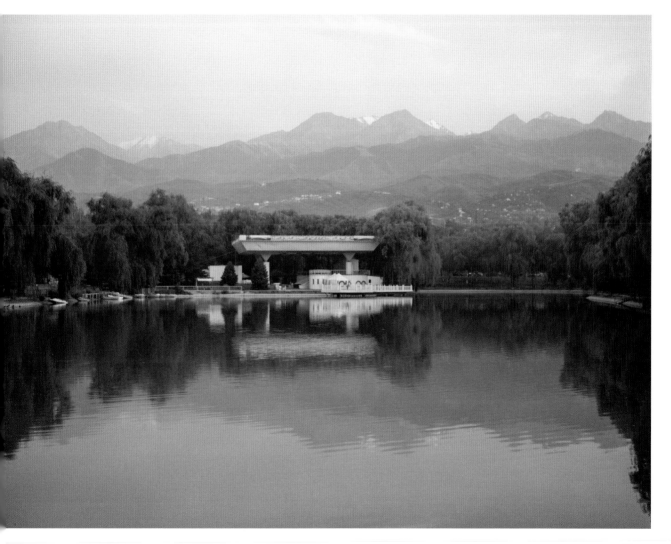

A sparsely furnished room where patients can rest between treatments or have a massage.

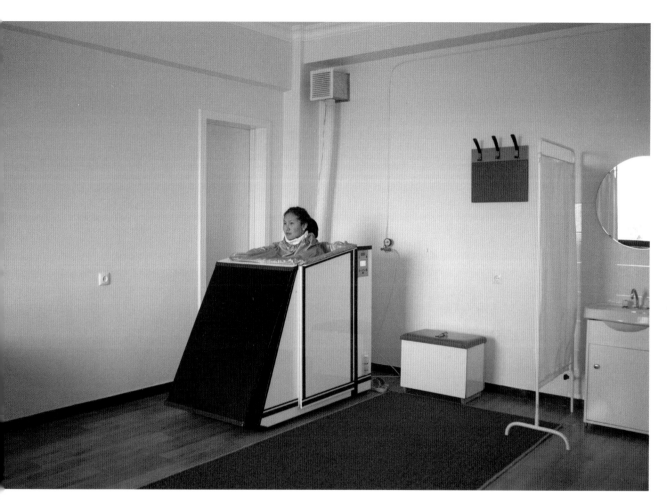

...atient takes a revitalising oxygen bath.

KYRGYZSTAN

After spying Lake Issyk-Kul from space, cosmonaut Yuri Gagarin was so enchanted that he was determined to visit as soon as he returned to Earth. Or so the story goes. This local legend may not be based on fact, but for anyone who has travelled to the almond-shaped lake in eastern Kyrgyzstan, it does not seem entirely implausible.

Ringed by the Tien Shan mountain range, Issyk-Kul is the second-largest alpine lake in the world after Lake Titicaca in South America. During the Soviet period, its eastern extremity was used as a torpedo testing ground, so much of the lake was out of bounds to foreigners. As Kyrgyzstan's showpiece, the area is home to the majority of the country's sanatoriums and continues to be a popular holiday destination.

During the hottest months of the year, Kazakh and Russian holiday-makers throng to the handful of sanatoriums that continue to operate, mostly along the lake's northern shore. During the rest of the year, these buildings are half-empty, popular only with Kyrgyz guests wishing to take advantage of cheaper off-season rates.

One of the poorest post-Soviet states, Kyrgyzstan has been wracked by political tensions, including two revolutions, since gaining independence in 1991. While some sanatoriums such as Aurora are state-owned, others such as Jeti-Ögüz belong to Kyrgyzstan's Workers' Union, providing subsidised stays for government employees such as teachers. Recalling the hypocrisy of the Soviet system, Saltanat Erkimbaeva, a resident of the nearby town of Karakol, says: 'I worked as a teacher for 35 years but never got a ticket to go. I always thought "maybe next year" but it never happened. In those days, it was mainly Russians who stayed in our sanatoriums.'

right: Ultraviolet light-emitting sterilisation lamps are placed in the ear, nose or throat to kill bacteria, viruses and fungi.

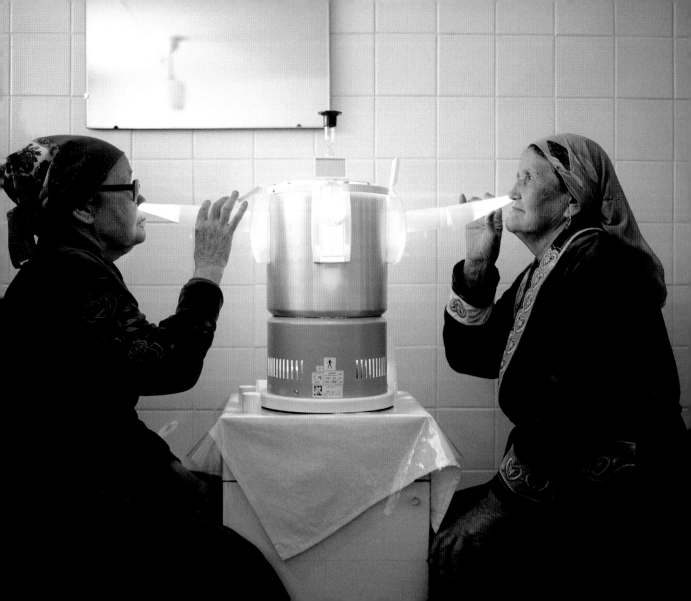

AURORA

The ship-shaped, brutalist Aurora is by far the most impressive sanatorium in Kyrgyzstan. This is no surprise, since it was built in 1979 exclusively for the Communist Party elite. At that time, more than 350 employees tended to every need of the 200 or so guests. 'From the moment they opened their eyes in the morning, they were surrounded by the best doctors,' says Erkinbek Borubaev, the sanatorium's current deputy director. Some claim the sanatorium was named after the battleship that fired the first shot in the 1917 Bolshevik Revolution, while others contend that Moscow architect Yuri Nikolaevich Minaev drew inspiration from *The White Ship*, a novel by celebrated Kyrgyz author Chingiz Aitmatov. The idea for the sanatorium came from Leonid Brezhnev, who owned a dacha nearby. Hidden in the basement, and accessible only on request, lies a museum-shrine to the former leader: his portrait stares from the photographs that cover every surface, surrounding other artefacts from the Soviet era.

Although the sanatorium is more egalitarian today, opening its doors to all paying guests, it is at the expensive end of the scale. Prices for top-floor apartments and cottages in the garden leading down to the beach reach $200 a night in August. The sanatorium is a mix of old and new: younger guests mill around in denims and velour tracksuits, while older visitors wear more traditional garb such as the *kalpak*, a white felt hat with black embroidery. Treatments too range from austere Soviet-style 'intestinal irrigation' (enema) to more modern offerings such as chocolate body masks. Several floors of treatment rooms provide the full gamut of therapies including balneotherapy, mud therapy, hydrotherapy, halotherapy (artificial salt therapy), physiotherapy, psychotherapy, neurology, gynaecology, dentistry and more.

clockwise from top left: With its sail-like parapet, the Aurora was designed to resemble a white ship.
Balneotherapy (bathing in mineral water) is a staple at most sanatoriums. It is claimed to help a variety of conditions including rheumatological and musculoskeletal diseases.
A Kyrgyz wrestler takes a swim in the pool before visiting the on-site gym for a work-out.

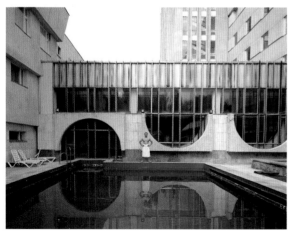

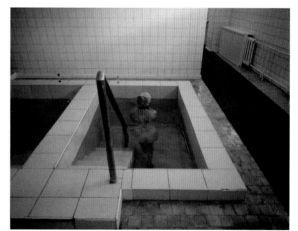

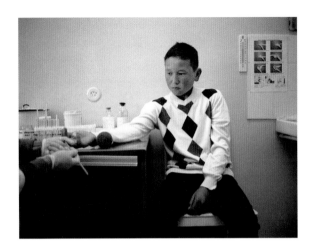

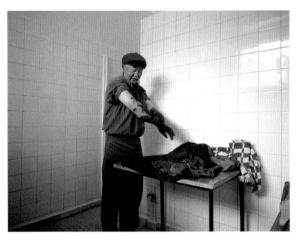

Blood samples are taken and sent for analysis.

Paraffin wax is applied to various parts of the body to relieve symptoms of osteoarthritis and arthritis.

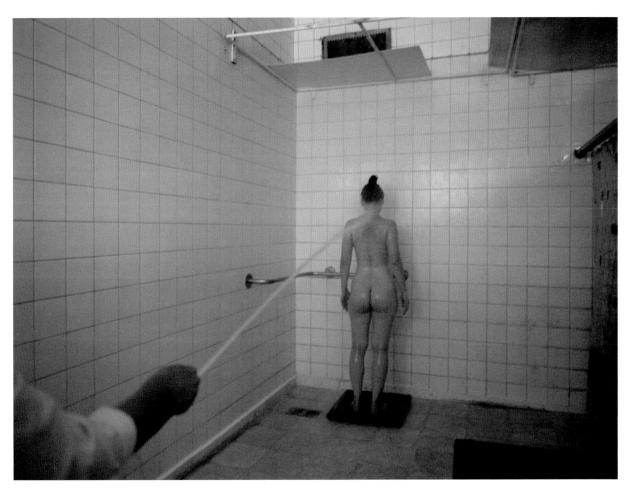

A patient is sprayed with a high-pressure hose, a treatment known as a 'sharko shower' (said to have been invented by the French neurologist Jean-Martin Charcot, 1825–1893), which helps to ease aches and pains.

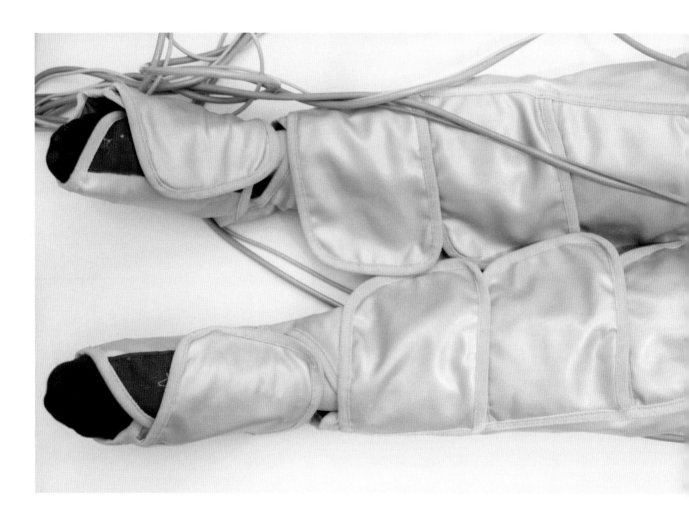

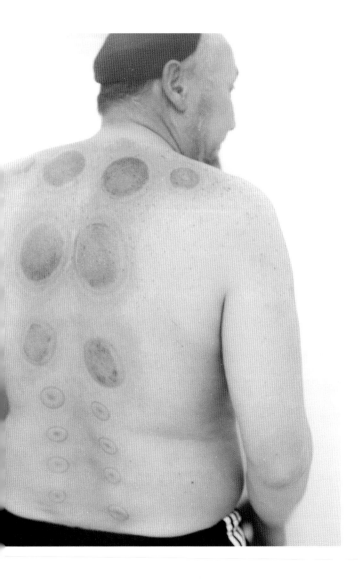

left: Bruises left after cupping treatment.
above: An electric comb used to stimulate hair growth.

far left: A patient receives electromagnetic therapy on
her legs, which reportedly helps with varicose ulcers
and chronic pain.

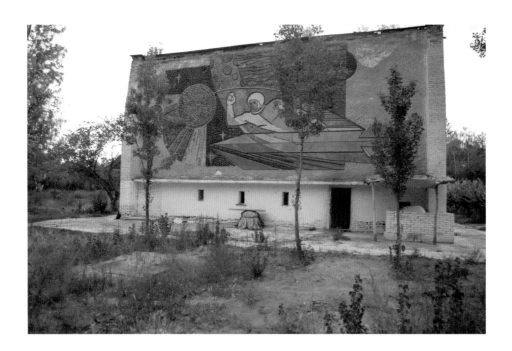

BLUE ISSYK-KUL

Named after the lake, Blue Issyk-Kul sanatorium in Cholpon-Ata on its northern shore was built in 1965, after local scientists discovered a patch of mud reputed to have healing properties. At its summertime peak, the sanatorium houses 1,000 people, mainly Second World War veterans and pensioners, who are treated free of charge for stays of up to three weeks. Depending on a patient's ailment, mud (the main attraction) is slathered over the appropriate area of the body – including the teeth and gums – before being washed off after twenty minutes.

above: Soviet murals glorifying workers or space travel were popular sanatorium design features.

ke Issyk-Kul, which never freezes, was once a stop on the Silk Road route. The mud on its banks is reported to have healing properties.

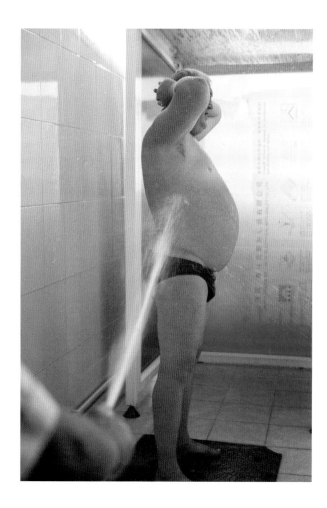

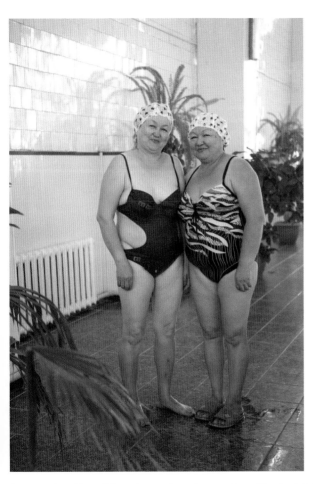

Water- and mud-based therapies are the main attraction at Blue Issyk-Kul. Guests can take indoor hydrotherapy or bathe in the lake itself.

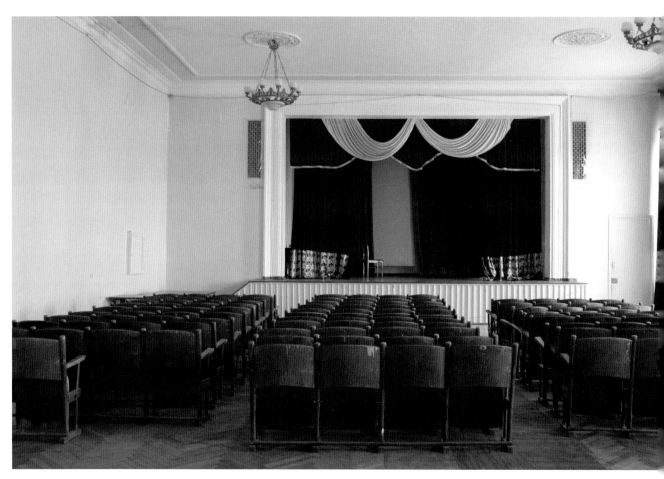

In the early days of the Soviet Union, entertainment of any kind was forbidden at sanatoriums; today it is considered an essential part of the experience.

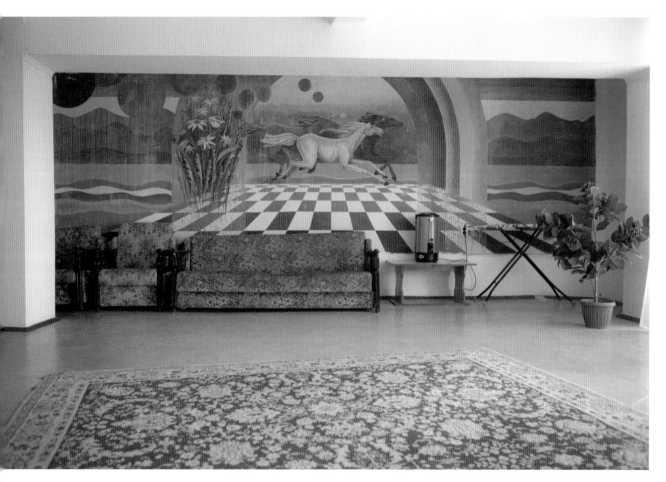

Communal areas provide visitors with spaces to sit and drink tea while chatting with other guests.

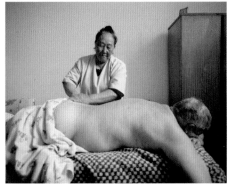

JETI-ÖGÜZ

What this run-down sanatorium lacks in comfort, it more than makes up for with the generous hospitality of the locals and the stunningly beautiful landscape. Built in 1932, it is named after the nearby Jeti-Ögüz gorge, a wall of seven red cliffs that are said to resemble seven bulls. According to folklore, the cliffs were formed after a king murdered his adulterous wife at a banquet where seven bulls were slaughtered.

As well as offering radon and hydrogen-sulphide treatments using local spring water, it is one of the few remaining post-Soviet sanatoriums to offer *kumis* – a drink made from fermented mare's milk, reputedly good for chronic diseases including tuberculosis and bronchitis.

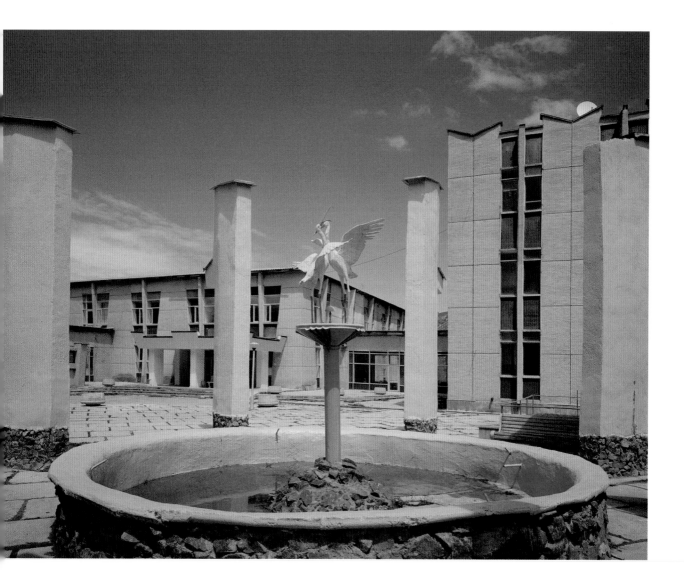

LATVIA

JURMALA

The seaside town of Jurmala, which stretches for 26 kilometres along the coast of the Gulf of Riga, has always been a place to see and to be seen. Once a favourite haunt of Soviet leaders Nikita Khrushchev and Leonid Brezhnev, today Jurmala is a playground for wealthy Russians, who are drawn to the region's lush pine forests and long stretches of white quartz sand, lapped by sapphire waters.

The sulphurous springs and therapeutic mud from nearby Kemeri have long attracted visitors to the area. Although the first bathhouse was built by Tsar Nicholas I of Russia in 1838, the conspicuous development of the region, from a string of small fishing villages into a leading spa town, did not get underway in earnest until the 1950s – more than a decade after Latvia had been annexed by the USSR.

Despite this late start, Jurmala rapidly became the Soviet Union's third-biggest spa town, after Sochi in Russia and Yalta in Crimea. At its peak in the early 1980s, it attracted around 350,000 patients a year. Two sanatoriums were built exclusively for the Communist Party elite and every summer the Soviet jet set would descend on the town. A cultural scene of concerts and poetry readings sprang up to entertain high-ranking officials, intellectuals, artists and writers. Today, just a handful of sanatoriums continue to operate, but unlike in the country's Baltic neighbours, Estonia and Lithuania, these have largely been preserved in their original form.

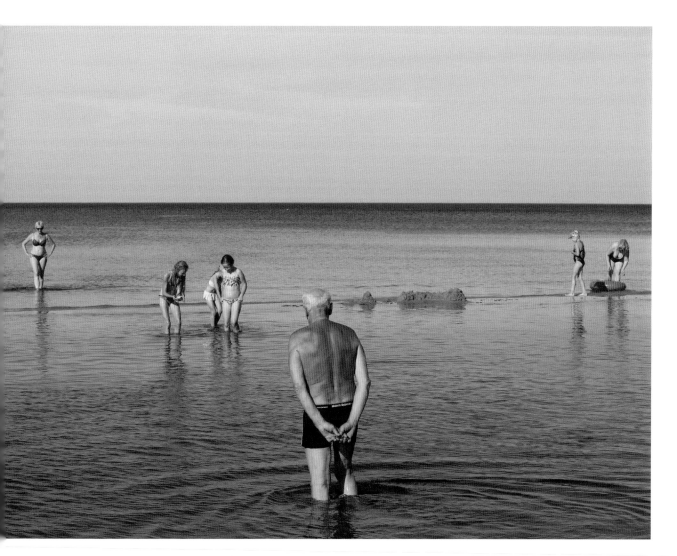

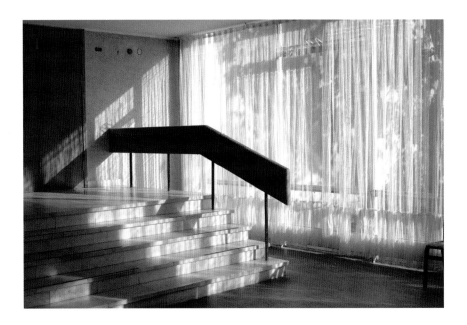

JANTARNIJ BEREG

Fragrant pine forests, white sand and cool sea breezes: Jantarnij Bereg has it all. The name of the sanatorium literally means 'amber coast', a nod to the golden nuggets that have washed up on the Latvian shoreline for centuries. Built in 1972 by the architect S. Kleymenov, today the sanatorium remains under the jurisdiction of the Russian Department of Presidential Affairs. It is frequented by government employees as well as other guests, who receive treatments to alleviate all kinds of diseases from cardiovascular to skin and respiratory problems.

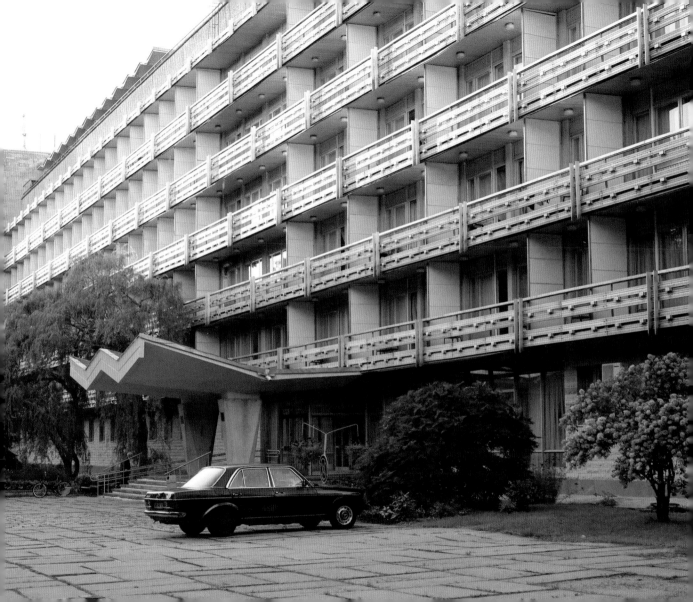

Accompanied by mineral water from local springs, sprats form part of national Latvian cuisine and are regularly served in the sanatorium canteen.

As well as the indoor café, there are areas for guests to sit and enjoy a foamy oxygen cocktail, said to boost energy levels and increase stamina.

The real highlight of Jantarnij Bereg is Government Dacha No. 2, a cottage in the grounds that in its heyday hosted the most powerful members of the Soviet Communist Party as well as high-ranking comrades from sympathetic countries such as the German Democratic Republic and Vietnam. Designed to accommodate both business and pleasure, the modernist dacha boasts its own indoor pool, library, billiard room, cinema and sauna. Its clean lines recall the work of celebrated Finnish architect Alvar Aalto and much of its glamorous and playful 1970s décor remains intact. A handful of statues and paintings of Vladimir Lenin complement the period furnishings.

left: A market is held in the corridors of the sanatorium twice a week. Here guests can buy anything from shampoo to dresses. During the rest of the week the shelves remain empty.
right: The dining room and living area of Government Dacha No.2. Now a museum, this Soviet-era cottage in the grounds of the sanatorium is perfectly preserved.

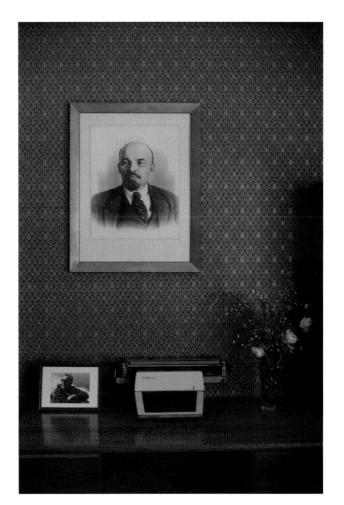

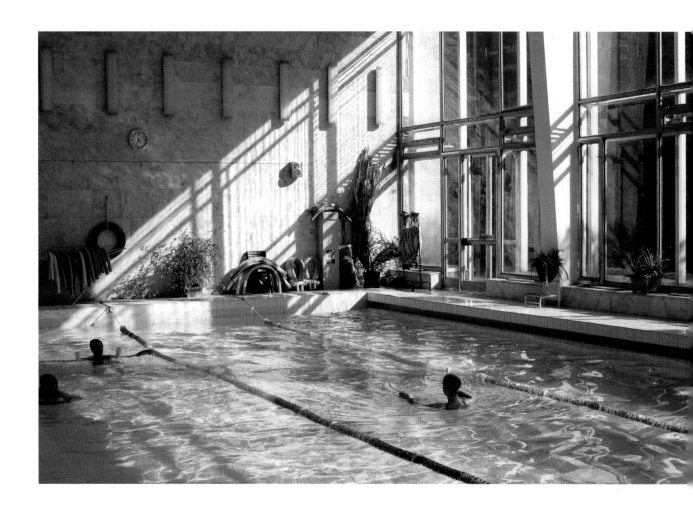

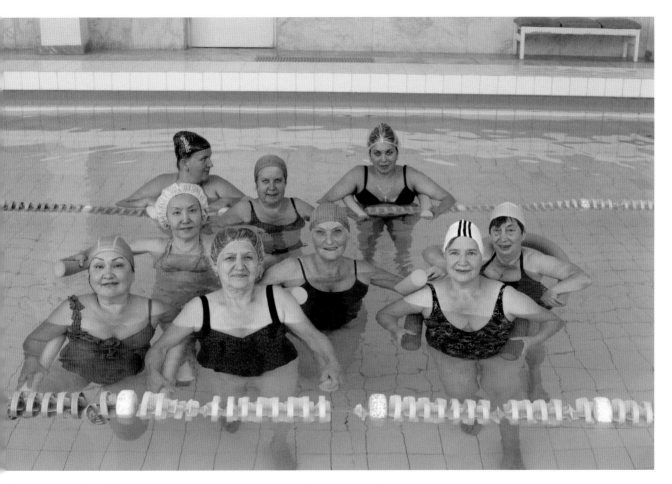

day, many sanatoriums offer more modern treatments and exercises such as water aerobics.

JAUNKEMERI

Surrounded by pine forests and just a short walk from the beach, Jaunkemeri sanatorium has been offering guests a peaceful escape since it opened in 1967. The sanatorium specialises in accident rehabilitation and is designed to accommodate individuals with mobility issues. As well as the salutary climate and remedies using mineral water and mud, the sanatorium also offers equine-assisted therapy – a psychological treatment that uses horses and horse-riding to help with healing.

left: Sodium chloride and sulfate baths are beneficial for the musculoskeletal and nervous systems.
right: Potted plants, a hallmark of Soviet decor, line the corridors.
The sleek architectural lines of Jaunkemeri are common to many sanatoriums in Jurmala.

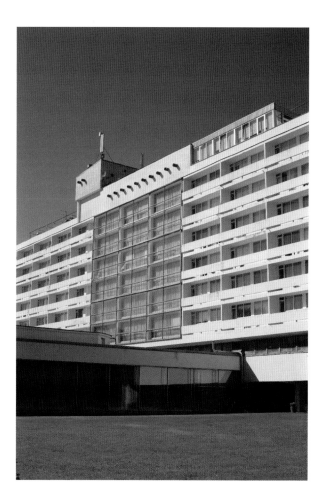

MOLDOVA

BUCURIA SIND

Originally intended as a summer resort for recreational activities, Bucuria Sind was converted into a sanatorium shortly after it was built in 1979. This decision was made in response to a growth in cardiovascular disease in Moldova, a country of just 3.5 million people sandwiched between Ukraine and Romania. Just 20 kilometres from the capital Chișinău, the sanatorium is located in the town of Vadul lui Vodă, which sits on the western bank of the Dniester river in a national park filled with pine and silver birch trees. During the Soviet period, millions of tons of sand were transported to the riverbank to create an artificial beach.

While the sanatorium continues to specialise in cardiovascular disease, it has expanded its range to include treatments for musculoskeletal, digestive, urinary, nervous and endocrine diseases.

above: A patient receives a massage.
right: A group of youths bathe in the Dniester river, close to the Bucuria Sind sanatorium.

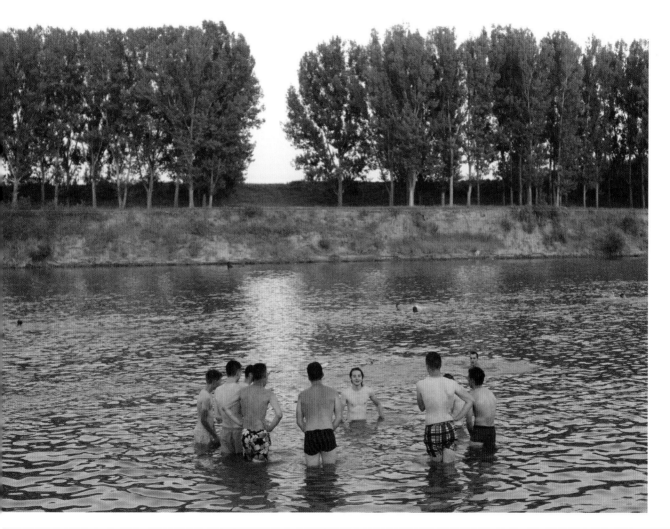

This irradiator uses ultraviolet light to disinfect noses and throats.

Hirudotherapy treatment uses leeches to relieve vascular congestion by draining blood.

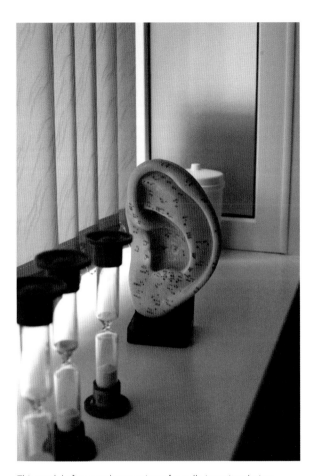

This model of an ear shows points of needle insertion during acupuncture treatment.

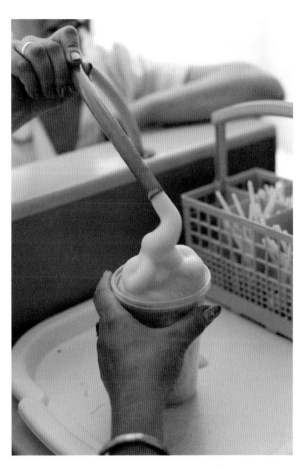

The sanatorium's sweet-tasting foaming oxygen cocktail is very popular with guests.

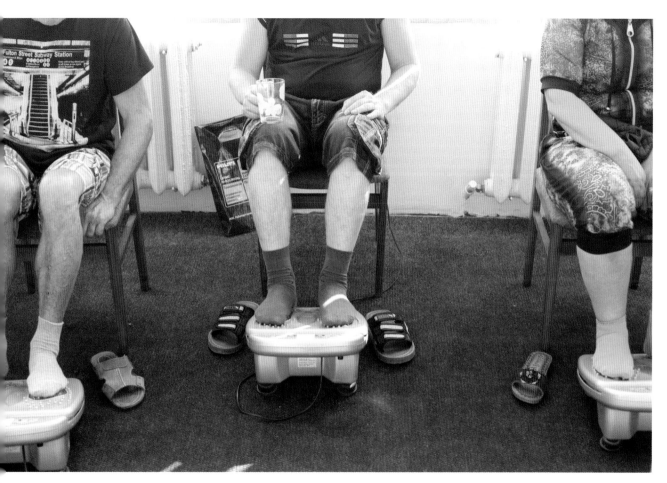

er therapies and treatments on offer at Bucuria Sind include aromatherapy, physical therapy and foot massage.

RUSSIA

ALYANS

In 2008, a 1.5-metre tall bronze monument to the enema was unveiled in the Russian town of Zheleznovodsk, where the procedure to treat digestive ailments is regularly performed at nearby sanatoriums. One of those offering the treatment is Alyans, a bathhouse and mud-bath clinic built in 1971. Located in the south-west tip of Russia, Zheleznovodsk is part of a group of towns collectively known as the 'Caucasus Mineral Waters' (alongside Pyatigorsk, Yessentuki and Kislovodsk). In the early 19th century they attracted convalescing military officers, who were followed by the Russian royal family.

With more than 60 iron-rich mineral springs in the region, mineral water continues to be the lifeblood of sanatoriums such as Alyans. Bathhouses and drinking galleries proliferate and, of course, enemas are offered wherever you go.

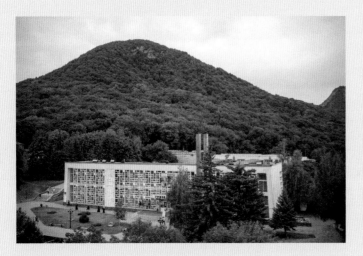

clockwise from top left: In Zheleznovodsk visitors can drink the famous mineral water straight from the source.
A young guest enjoys a mineral-water bath.
Low-frequency magnetic fields are believed to cure all manner of ailments including fractures, rheumatism, psoriasis and even schizophrenia.
A patient undergoes full-body magnetic therapy to boost the immune system.

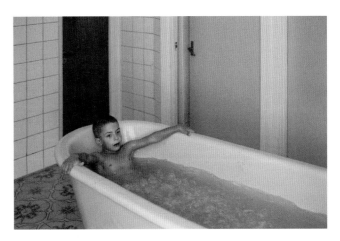
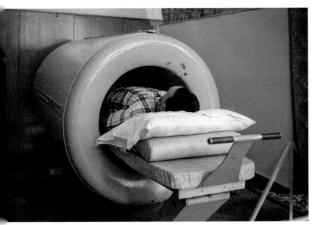
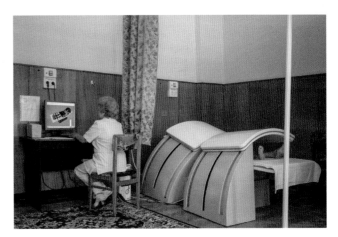

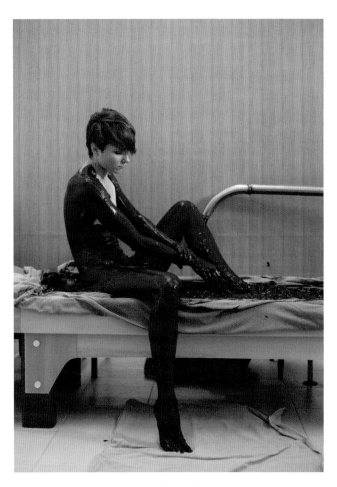
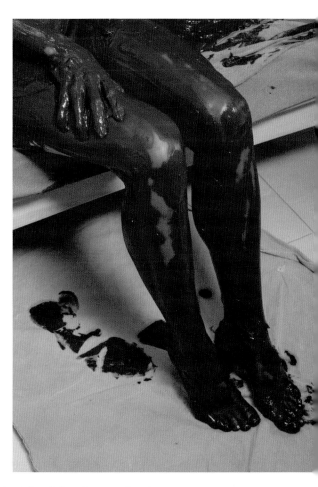

Mud therapy is a speciality at Alyans, where the sticky substance is piped directly from the source into the treatment rooms.

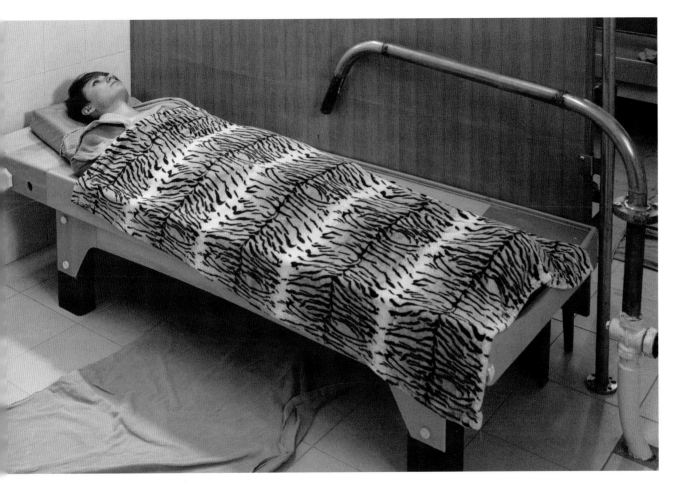

After being covered in warm mud, patients are wrapped with a thick blanket. This retains the heat for between ten and fifteen minutes.

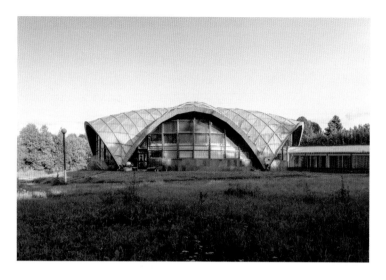

KLYAZMA

During the 1960s, as Soviet citizens began to work a five-day week, there was increasing demand for weekend *pansionats* (resorts) that did not require the *putevki* (vouchers) needed for a standard sanatorium visit.

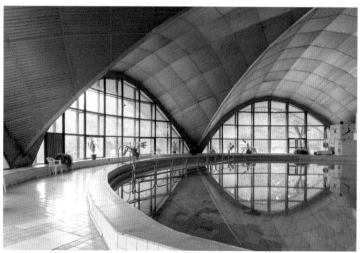

Although not strictly a sanatorium, Klyazma is evidence of this new development. Built in 1963, it forms part of a group of four *pansionats* (the others being Berezki, Podmoskovya and Dubrava) constructed around the Klyazminsky Reservoir on the outskirts of Moscow to provide the benefits of sanatoriums close to the city.

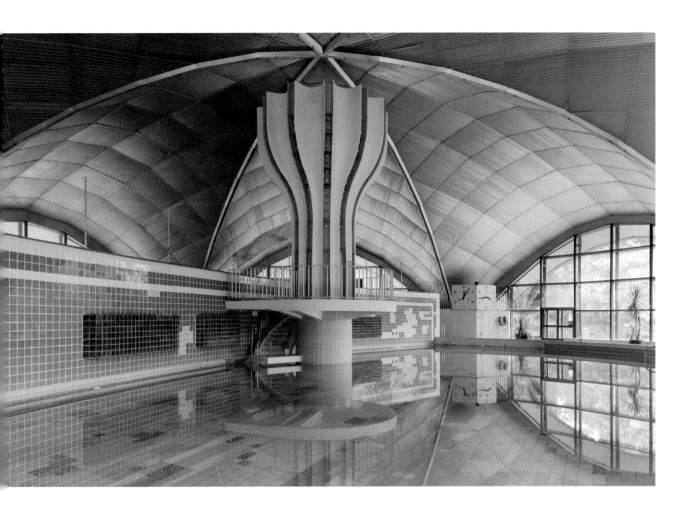

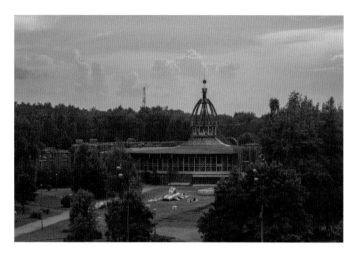

LIPKI

Located in the swampy Moscow region of Zvenigorod and surrounded by pine forests, this red-brick building was commissioned in 1986 by the Transport and Construction Ministry. Conceived primarily as a children's summer camp with a capacity of 500, it accommodated up to 340 adults during the rest of the year. Lipki was a bold experiment in design at a time of great change in the USSR. From above, the sanatorium resembles a squid, with wings extending like tentacles from a central rotunda housing a winter garden.

Although the sanatorium now boasts 21st-century touches such as an internet café, it still has one foot in the past: the Soviet-era nightclub – prosaically named 'Night Club' – is still running and guests can expect to receive liberal servings of vodka and brandy during lunch hours.

above: The striking rotunda houses a winter garden. A patient's toes are nibbled by a type of carp called garra rufa, during a fish pedicure treatment.
right: Guest help themselves to buffet-style meals served in the large dining hall.

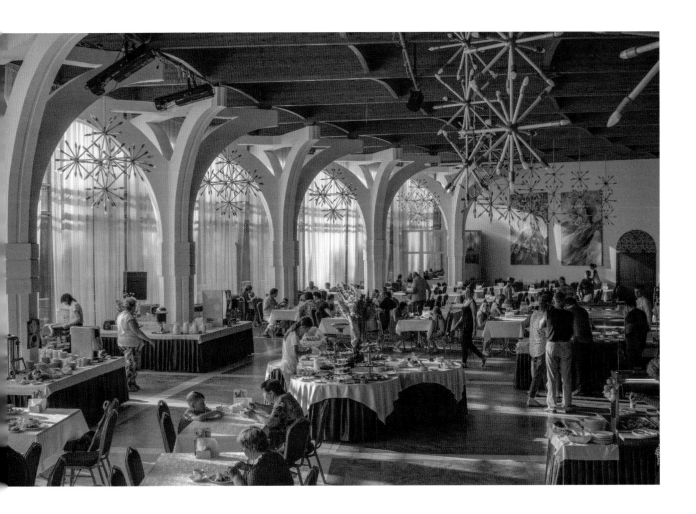

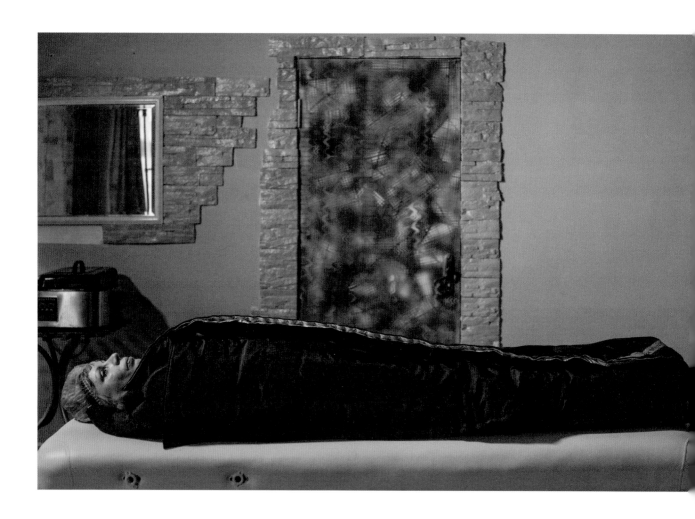

124 Lipki, RUSSIA

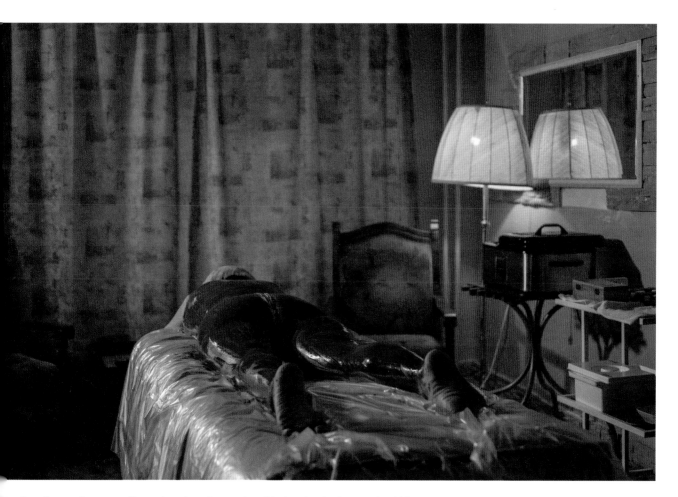

A number of sanatoriums now offer modern therapies – such as this chocolate body wrap – in a bid to attract younger guests.

RESHMA

In his search for the perfect location for a new sanatorium, Yevgeniy Chazov, head of the USSR's Ministry of Health, stumbled on a glade near the village of Reshma. In this idyllic clearing, just a short distance from the Volga river, he commissioned the construction of a red-brick sanatorium that resembles a modernist castle. Architect Valery Bruncev is pragmatic about the inception of his creation: 'It wasn't about inspiration, but necessity. It was necessary because there was nowhere to go with a child under fifteen. It was the kind of sanatorium space that was needed.' Bruncev adds that there was 'no ideology' involved in the design. 'I wasn't given any specific instructions,' he says.

After opening in 1987, the sanatorium rapidly earned a reputation for excellence – both as an outstanding location for rehabilitating cosmonauts and as a rest home for 'liquidators', the name given to those tasked with cleaning up the aftermath of the Chernobyl nuclear disaster. Over time, staff developed a rehabilitation programme for victims of radiation exposure that was adopted across the country. But Bruncev's outlook for the future of sanatoriums is gloomy. 'It's barely funded by the government,' he says. 'It's difficult everywhere now. Everyone's going abroad. Maybe over time things will change, but the collapse of the Soviet Union impacted badly on Reshma.'

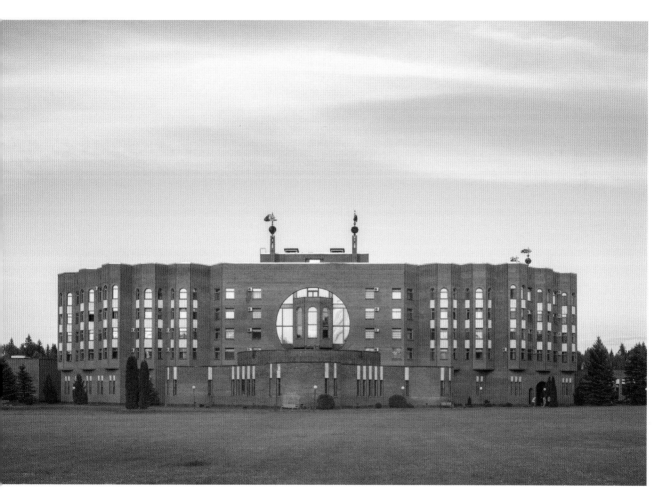

ıma sanatorium was designed as a modern, red-brick interpretation of a castle.

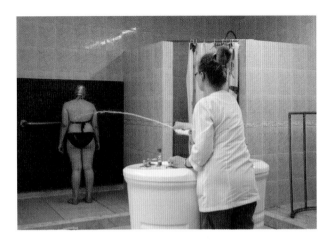

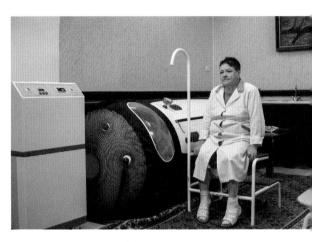

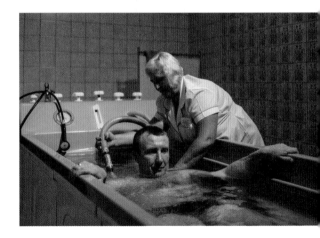

top: A high-pressure 'sharko shower', relieves aches and pains.
bottom: Guests relax in a common area decorated with icons.

top: Hyperbaric oxygen therapy is used to treat decompression sickness, carbon-monoxide poisoning and even autism.
bottom: A guest receives a hydromassage.

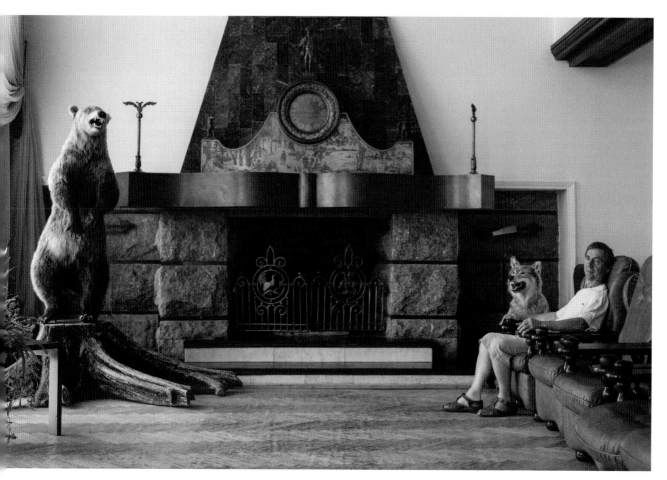

common areas on each floor are decorated according to different themes, in this case, hunting.

RODNIK

Encircled by miles of thick forest within a mountainous landscape, Rodnik, like Alyans, specialises in water-based treatments. Built in 1982, the sanatorium is today owned by the Federation of Independent Trade Unions of Russia. It is located 510 metres above sea level at the base of Mashuk, an isolated peak in Pyatigorsk, another of the spa cities that make up the 'Caucasus Mineral Waters'. Its popularity is due to the range of mineral-water-based treatments on offer: everything from bathing and douching to drinking and inhaling.

left: A guest takes an oxygen steam bath. The treatment is reported to aid slimming by burning calories, as well as reducing the appearance of cellulite and other skin conditions.
right: A hyperbaric oxygen therapy chamber (see page 128).

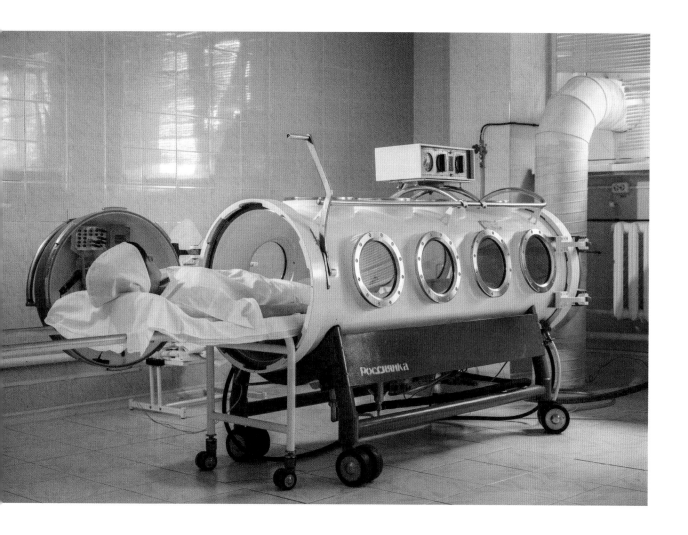

SOCHI

With its swaying palm trees and balmy Black Sea climate, Sochi has been a popular retreat since the late 19th century, when Russian aristocrats holidayed there during the summer months. It was not until the 1930s, however, that the subtropical city, dubbed the 'Russian Riviera', came into its own. In 1933, writes Diane Koenker in *Club Red*, Joseph Stalin gave the go-ahead for Sochi's transformation from a swampy backwater into a monumental socialist showpiece, designed to parade Soviet attitudes to rest and relaxation to the world. With no expense spared, the USSR's finest architects were enlisted and building began on some of the era's best, and certainly most lavish, sanatoriums.

By 1959, 46 new sanatoriums had been built in Sochi. While some, such as Metallurg and Ordzhonikidze (pages 144–149), epitomised the decade's penchant for neo-classical pomp, featuring decorative porticos, columns and fountains, others, such as the Voroshilov sanatorium (page 152), drew inspiration from the Soviet Union's recent Constructivist past. Built in 1934 by architect M. I. Merzhanov and containing a funicular leading from the sanatorium to the beach, Voroshilov went on to win the Grand Prix at the World's Fair in Paris just a few years later. 'The sanatorium in its entirety is an enormous organism, a real factory of health, returning the strength of many thousands of workers of our country,' said M. I. Rusakov, an engineer at the Design Sector of the Institute of Kurortology, which oversaw construction around the Matsesta waters (page 138; translation by Geisler).

In reality, only a few lucky workers made it to this pearl of the south, for treatment by the world's 'most miraculous doctors', writes Koenker. Usually, the city's health resorts were reserved for the Soviet elite, including cosmonauts and star athletes. In addition, a closed network of sanatoriums was built exclusively for key members of the Communist Party. In 1965, the city was named 'best resort of the Soviet Union'; in the words of one gushing guest, Sochi was 'not life, but paradise!' Music, theatre and film thrived, catering to the influx of a sophisticated, high-ranking clientele. According to Koenker, holidaying in Sochi also provided a space for more permissive attitudes to prevail. 'What happened in Sochi stayed in Sochi,' she writes, adding that the city 'became a kind of magical place, a kind of Shangri-La depicted as the dream place.' The saying 'Everybody should visit Sochi, even if it's only once in your life' is still heard today.

right: The pyramid-shaped Dagomys sanatorium and the circular Olympic Dagomys Pansionat.

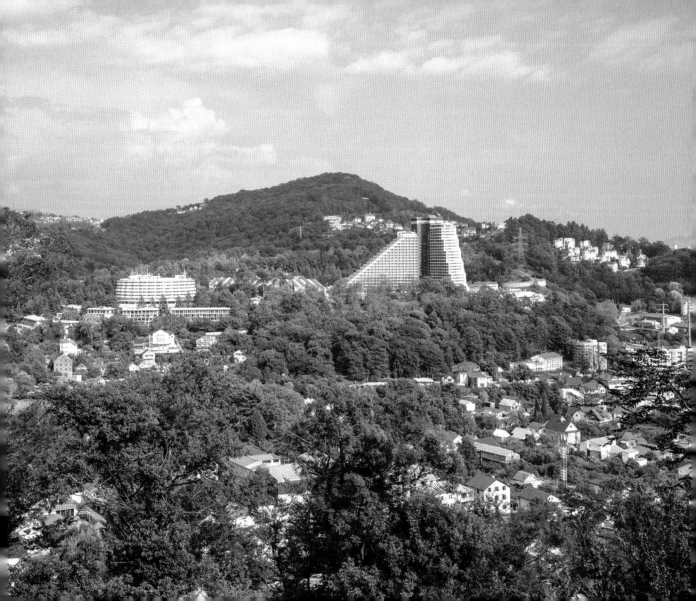

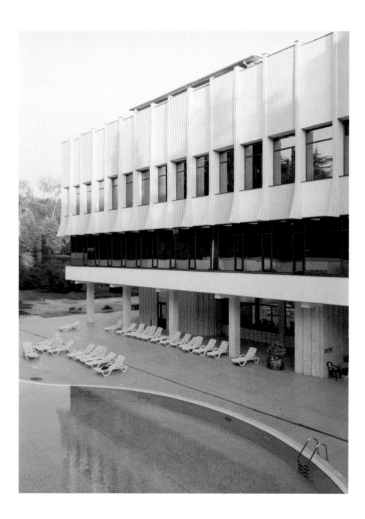

BELARUS

Originally constructed in 1939, with further buildings added in the 1960s and 1970s, Belarus sanatorium displays a bewildering range of architectural styles, from neo-classical to modernist. Set in over 15 hectares of botanical garden, it was originally offered as a haven for writers and artists. In addition to climate therapy, the sanatorium specialises in treating cardiovascular, musculoskeletal and skin diseases.

right: A guest undergoes magnetic therapy. Considered a pseudo-treatment in the western world, this is a popular therapy in sanatoriums where it is used to alleviate symptoms of pain across a range of diseases.

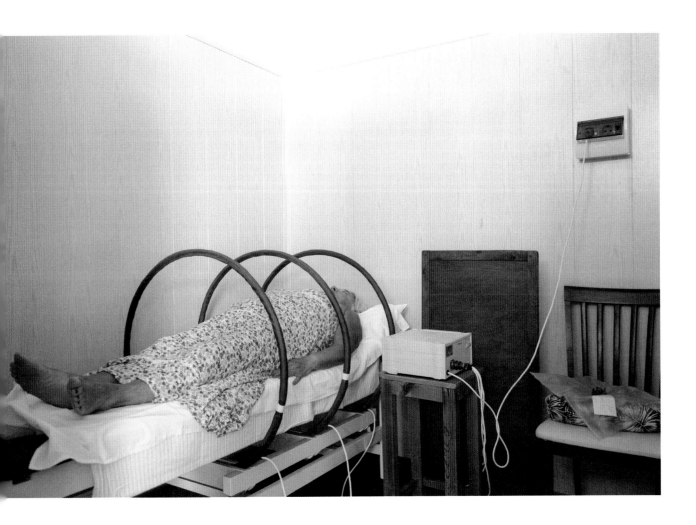

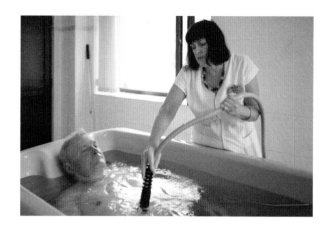

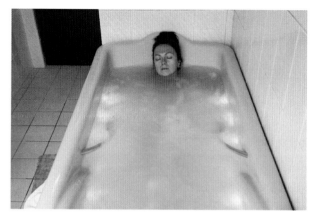

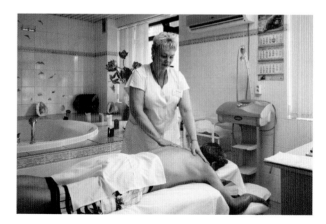

top: Hydromassage is one of the most popular treatments.
bottom: A patient sits in an oxygen bath.

top: A woman relaxes in a mineral-water bath.
bottom: Today, spa-like treatments such as massage are common.

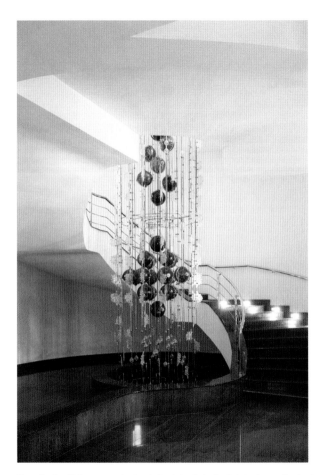
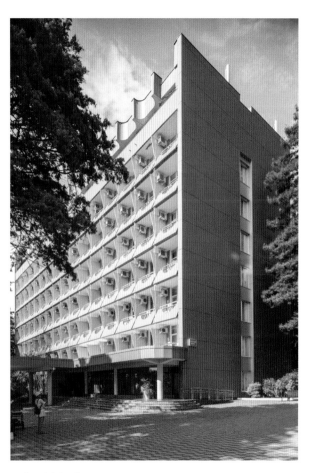

Despite the Belarus sanatorium's Soviet origin, both interior and exterior are well maintained.

MATSESTA

The first thing that hits you as you enter Matsesta is the stench of rotten eggs, a product of the sulphurous spring water that has enticed visitors since the early 1900s. Although it is not strictly a sanatorium (there are no rooms for guests to sleep in), Matsesta is something of a Sochi institution. It is the 'heart of Sochi', wrote the health resort's first party secretary in 1967; without it, sanatorium culture would arguably not have flourished here.

In 1940, under Stalin's grand plan for Sochi, architect A. P. Golubev built a crescent-shaped treatment centre in Matsesta, using the Soviet leader's favoured Empire style. Soon the healing powers of Matsesta's prized waters became known across the Soviet Union and beyond. In its 1960s heyday, the centre was open from 6am until 11pm, treating several million patients a year. Guests would queue for hours to bathe in the murky spring waters, described by Dr Alexander Mikhailov – who has worked at Matsesta for close to three decades – as 'nature's own underground pharmacy'. Although blackened by the high iodine content, the water temporarily turns the skin a bright red, hence the name Matsesta, which means 'fire water'.

The centre was frequented by many high-profile figures. Soviet premier Leonid Brezhnev ordered a wooden platform to be made, so his posterior wouldn't come into contact with the bathtub while he bathed. Stalin, who suffered from chronic rheumatism and hypertension, had separate lodgings and treatment rooms built for his exclusive use. However, following word of a planned assassination attempt, he never stepped foot in them, electing instead to stay in the building now occupied by the administration office. The specially constructed quarters did not go to waste – even today, the pale yellow, neo-classical building is in constant use by visiting dignitaries.

right: Matsesta's hydrosulphuric spring waters are hailed as a cure-all by locals. They claim the waters alleviates all manner of diseases, from skin conditions to nervous disorders and even syphilis.

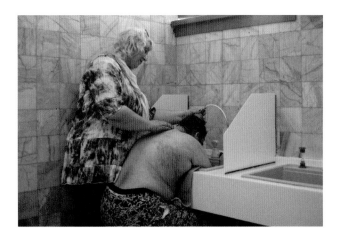

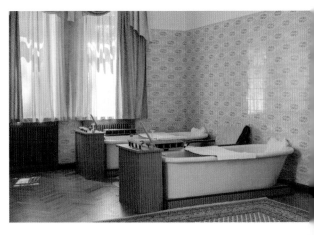

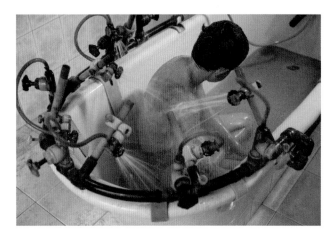

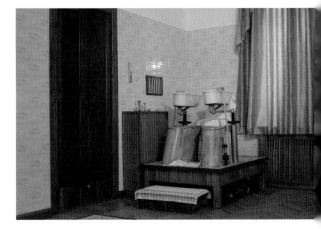

top: A man is showered with Matsesta water to boost blood circulation.
bottom: A boy receives Matsesta water treatment for scarring from burns.

A separate house was built nearby exclusively for Stalin; however, the Soviet leader never stayed here for fear of assassination.

This wooden platform was specially made for Soviet premier Leonid Brezhnev, who preferred to avoid direct contact with the bathtub.

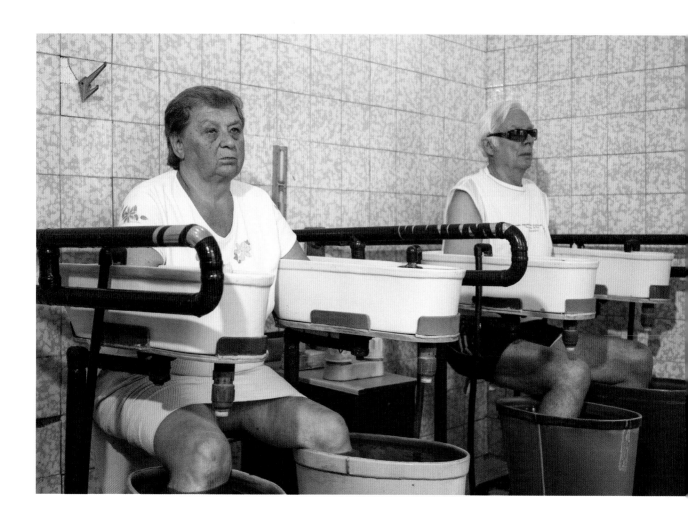

Matsesta, Sochi, RUSSIA

Today patients at Matsesta use nearby hotels, apartments or sanatoriums as a base from which to visit the treatment centre, which is still owned by the Federation of Independent Trade Unions of Russia. The renowned water is hailed as a universal remedy, with specific efficacy in the treatment of burn scars. Despite Matsesta's continued popularity, Mikhailov laments the decline of sanatorium culture, with visitors to Sochi more interested in skiing and sunbathing, depending on the time of year: 'Maybe in the future snowboarders will come here if they experience any problems – if there still is a Matsesta, that is. The art of balneology is dying out and there's no one to replace us.'

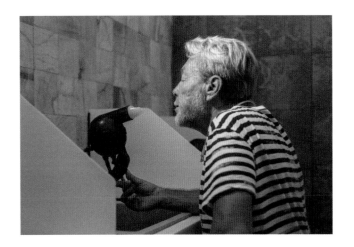

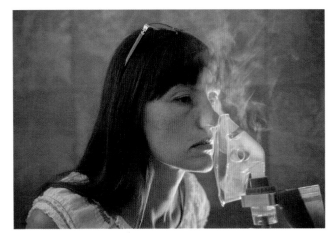

left: For patients unable to endure the heat of a full mineral-water bath, this topical treatment allows the submersion of just arms and legs.
top right: Steam from Matsesta spring water is inhaled through the nose; this is said to be beneficial for respiratory conditions. Patients are advised to keep a distance from the potent steam to prevent an excessive dose.
bottom: The spring-water steam treatment is followed by herbal-oil inhalation.

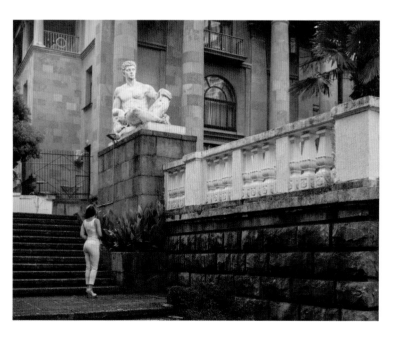

METALLURG

In 1956, Metallurg, one of Sochi's most striking sanatoriums, opened on Kurortny Prospekt, the city's main avenue. The neo-classical building, designed by Jacob Svirsky and Georgy Bitov, epitomised the shift in Soviet architecture towards incorporating the natural environment as a means of reviving the human spirit. The sanatorium, which overlooked the sea, was one of the first to include an indoor saltwater pool for use in the winter months. Large windows allowed light into the interior of the building, while perfectly manicured gardens were filled with subtropical flora, with a broad cascading staircase leading to a central fountain. The pride of Sochi, Metallurg became an essential feature on the itinerary of all foreign guests.

Built under the auspices of the Ministry of Metallurgy, it was originally designated for

left: The neo-classical architecture of Metallurg sanatorium. The large windows allow interiors to be bathed in light, an essential part of climate therapy, championed by the Soviets.
right: Sochi's skyline was transformed by a spate of new developments ahead of the 2014 Winter Olympics.

the exclusive use of metalworkers. However, today the sanatorium is owned by the Federation of Independent Trade Unions of Russia and is open to everyone. The range of its medical facilities has also expanded since the Soviet era, when it specialised in cardiological, neurological and dermatological treatments. Like Matsesta, Metallurg now treats burn victims, as well as offering many other remedies such as oxygen and mud therapies.

The Soviet philosophy that prevention is better than cure still prevails. According to general director Chepurnaya Grigoryeva, 'There is a future in sanatoriums because they are unique as a form of preventative medicine. It's not just about medicine though – climate and natural landscape also have a part to play.'

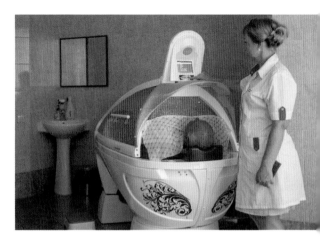

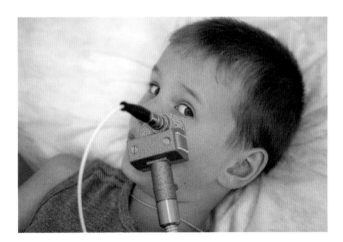

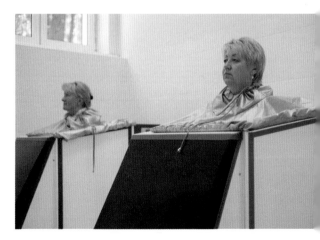

bottom: A young boy receives electromagnetic treatment.

top: A spa capsule used for either dry hydrotherapy or hydromassage.
bottom: Oxygen steam baths.

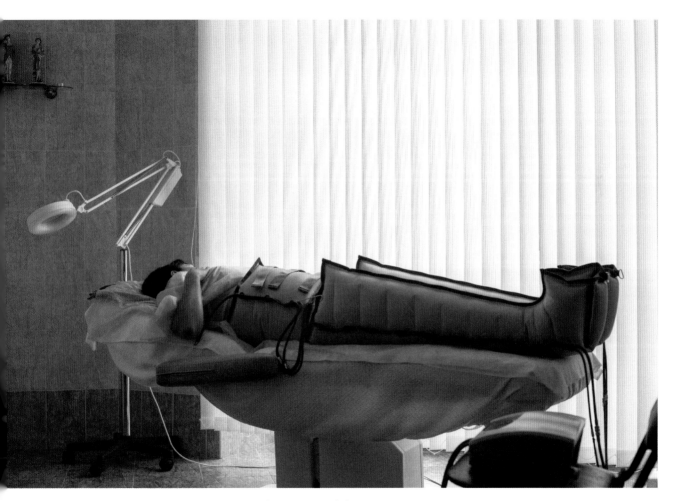

ymphatic-drainage suit allegedly boosts blood circulation and promotes weight loss.

ORDZHONIKIDZE

In the Soviet film *Old Khottabych* (1956), a genie appears at Ordzhonikidze and mistakes it for a royal residence. He is quickly put right by a guest, who informs him that this is a 'palace for workers and peasants', not kings. With its sweeping staircase, highly ornamental façade and fountain filled with dancing nymphs, the sanatorium was the star of Sochi when it was built in 1936. In its prime it also boasted a heated open-air seawater pool and an outdoor cinema for 500 guests.

Originally named Narkomtyazhprom (a portmanteau for the People's Commissariat of Heavy Industry) and later renamed after Grigory Ordzhonikidze (a Georgian Bolshevik and friend of Stalin), the sanatorium was designed in theory to be palatial yet open to all workers. In practice, however, it was as exclusive as every other sanatorium in Sochi, with the majority of rooms occupied by guests with good Party connections.

Currently under renovation, but with no completion date in sight, Ordzhonikidze today is little more than a Potemkin Village, a majestic shell concealing shabby interiors. Its magnificent grounds are frequented mainly by couples getting married, who pay the management a few roubles to have their photographs taken with the nymphs.

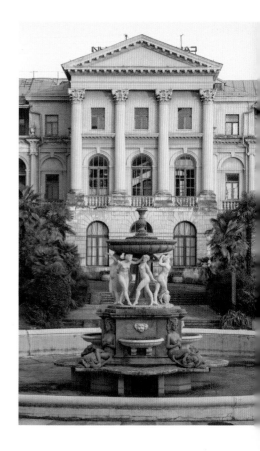

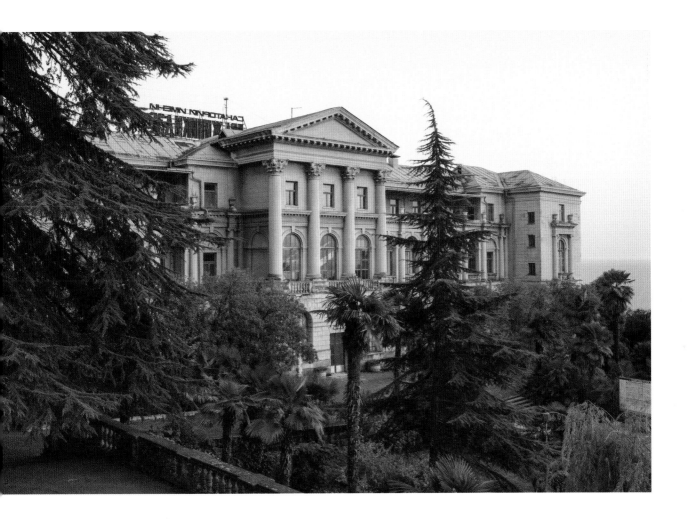

above: At the base of Mount Akhun, Sputnik sanatorium offers guests a peaceful retreat 20 kilometres from Sochi's bustling city centre.
right: Towering Stavropol sanatorium offers guests sweeping views across the sea as well as their own stretch of private beach.

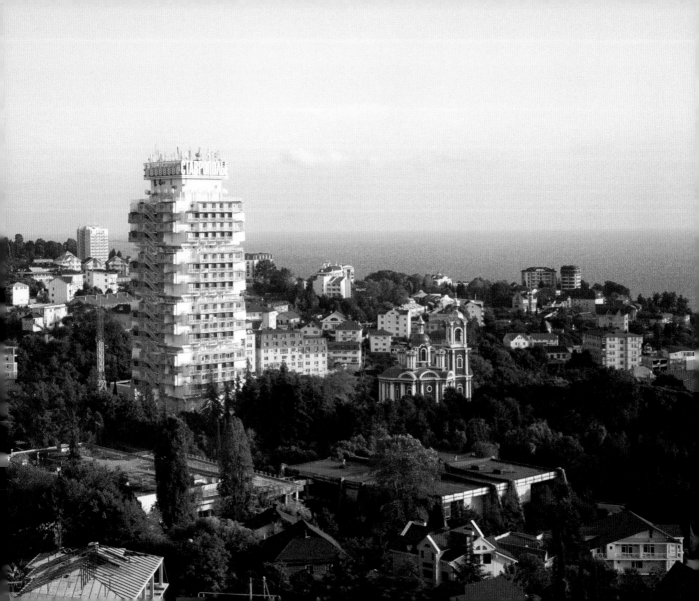

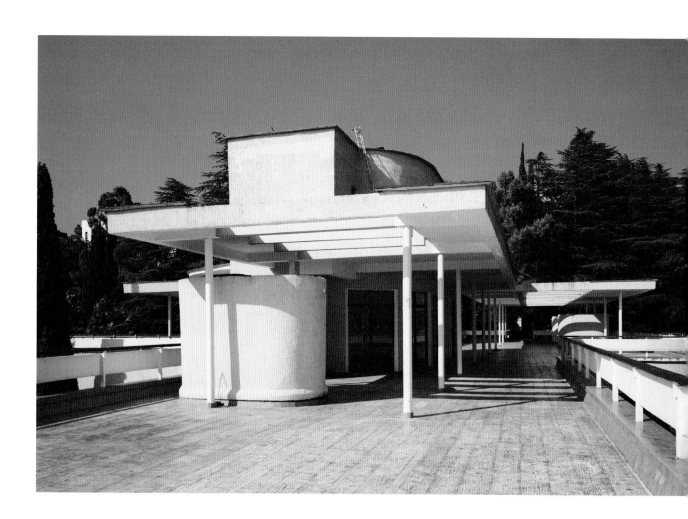

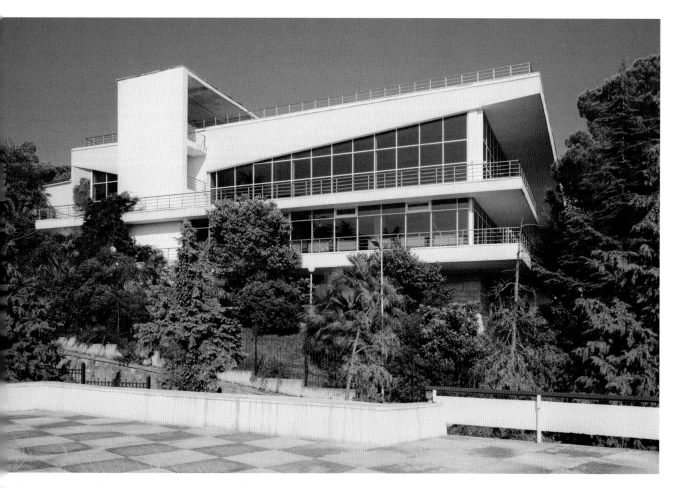

The Constructivist icon Voroshilov, designed by architect M. I. Merzhanov in 1934, won the Grand Prix at the Paris World's Fair of 1937.

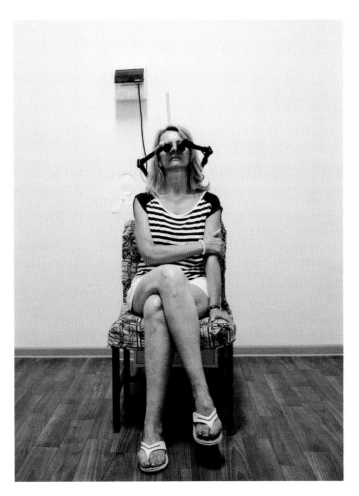

WHITE NIGHTS

For about three months a year from May to July, the Russian city of St Petersburg is bathed in a 24-hour glow by a sun that never quite sets, a phenomenon known as the 'white nights'. Despite being more than 2,000 kilometres distant from St Petersburg, White Nights sanatorium in Sochi manages to capture some of the northern city's summer-time charm. The white modernist sanatorium, built in 1978, is set amid a lush botanical garden that spills over on to a stretch of private beach, providing guests with either sun or shade, to match their mood.

left: Ultrahigh-frequency therapy is used on the face to relieve symptoms of sinusitis and can also be used to cosmetically tone the skin.

opposite, clockwise from top left: Low-frequency magnetic therapy reportedly helps with blood pressure and circulation, as well as the nervous and urinary systems.
Ultrahigh-frequency magnetic therapy is used to treat a range of conditions such as inflammation.
A lymphatic drainage suit used to aid weight loss.
A patient undergoes magnetic therapy to help the central nervous system to function.

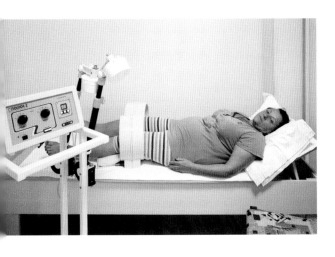

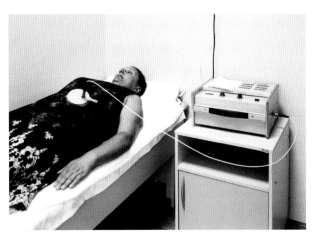

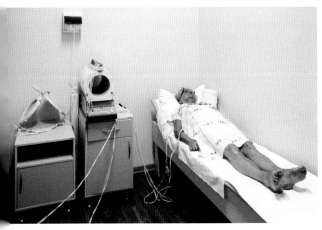

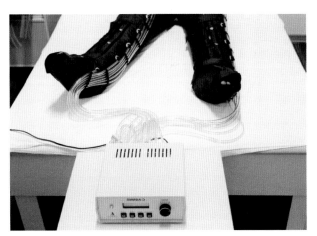

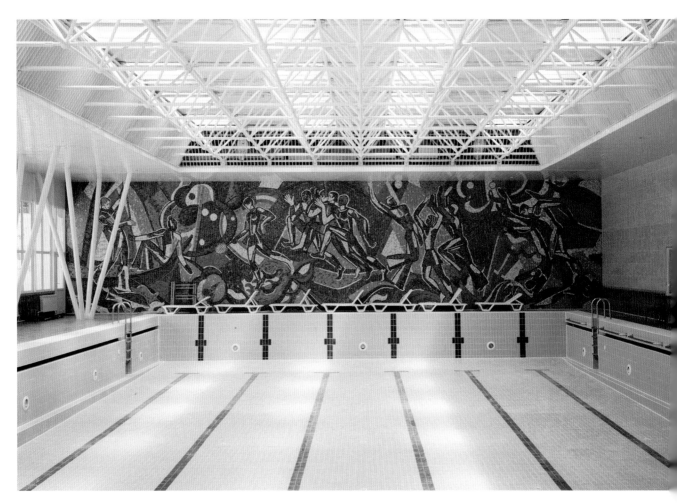

The swimming pool retains its Soviet-era mosaic mural.

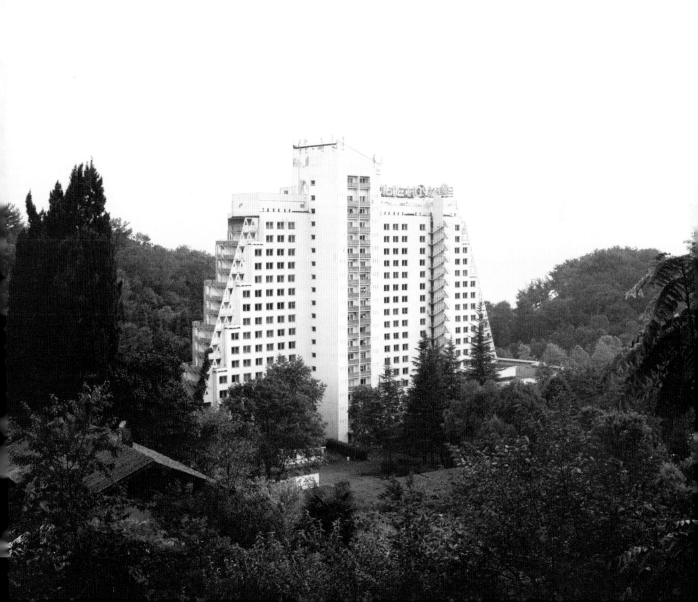

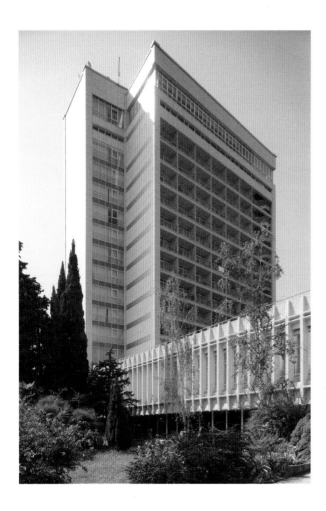

ZELENAYA ROSCHA

Although only a few decades old – the sanatorium was built in the 1980s – Zelenaya Roscha, which means Green Grove, was thoroughly modernised in 2011. Today it offers guests a luxurious stay in the middle of a national park close to Sochi's city centre. A main attraction is its proximity to Stalin's holiday residence, where the Soviet leader reportedly spent his summers right up to his death in 1953. The decoration of the dacha reveals the level of Stalin's paranoia: it was left uncarpeted so he could hear trespassers' footsteps and painted green for camouflage.

is building houses the elevator that takes guests directly to the beach.

TAJIKISTAN

KHOJA OBI GARM

Nothing quite prepares you for the first view of Khoja Obi Garm, a hulking brutalist building nestled high in the Gissar mountain range. It opened in 1934 on a site further down the mountain, before being relocated to the summit (at an altitude of 1960 metres) 40 years later.

The main building, erected in 1982, is a colossal concrete mass. Inside, corridors stretch in every direction, a sprawling warren with no apparent end. Within this labyrinth, the reception desk provides a meeting point. Here teams of young men wearing suits and sporting Beatles-style haircuts welcome you with their hands placed on their chest – a sign of deference in Tajikistan, the poorest country in Central Asia.

Guests travel from all over the country to what they refer to as the 'magic mountain', where radon water flows from several underground sources. While radon has received bad press in the west as a possible cause of lung cancer, it is also acknowledged to have analgesic and anti-inflammatory properties. At Khoja Obi Garm, it is seen as a panacea for all ills, including arthritis, blood pressure and infertility.

The focus of treatments such as radon baths and radon douches, the water is also pumped into the bathrooms of the 325 spartan guest rooms. Almost every common room is adorned with a portrait of president Emomali Rahmon, whose private dacha is just a few hundred metres away. The neo-classical building, with sand-coloured walls and bright white columns, is as pristine as the sanatorium is decrepit.

The sanatorium's employees, most of whom live on the mountain, extol the water's miraculous healing powers. An information booklet hails the site as 'the eighth wonder of the world', while the pharmacist, an employee of 32 years, insists that this is the only place on earth where such water can be found. Sharaf Naziruf, a young, skeletal doctor, who at almost 2 metres tall towers over most Tajiks, jokingly points to his height

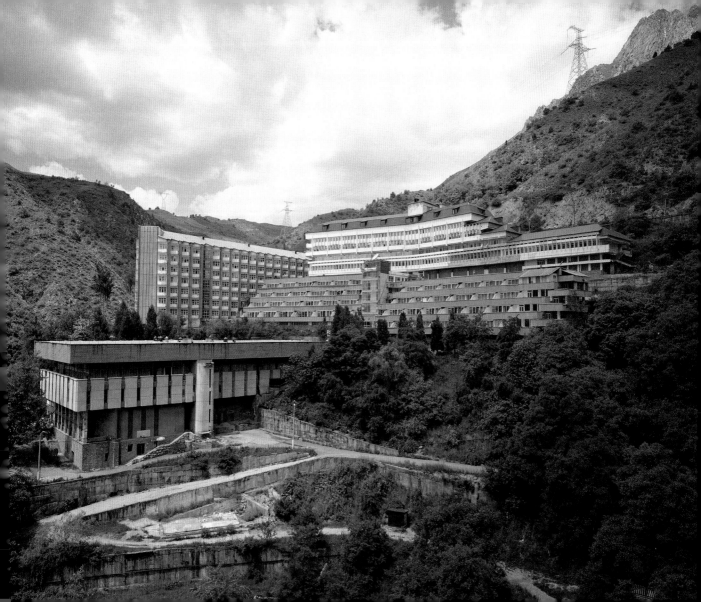

as evidence of the water's health benefits: 'I grew up with this water, we played in it as kids. We showered in it and washed our dishes in it.' For those unconvinced by the marvels of radon, other treatments such as the ominously named 'electrical hot chair' and 'friction and shaking with medical electrical equipment' are also on offer. Unexpectedly, the sanatorium has become a rehabilitation centre for local drug users, who are locked away in one of the many rooms until they are cured of their addiction.

Unlike other post-Soviet sanatoriums, Khoja Obi Garm has a distinctly conservative air. Islam is the main religion in Tajikistan and guests fill the prayer room several times a day. Both men and women dress in traditional clothing, the men wearing kaftans and skull-caps, reminiscent of Afghan dress, and the women harlequin-coloured outfits similar to the Indian subcontinent's shalwar kameez, topped with headscarves tied bandana-style. Although treatments are segregated by sex, everyone comes together at mealtimes and for the evening's entertainment, which includes plays, poetry, singing and dancing. The traditional Tajik dancing – all swirling bodies and serpentine hand movements – is completely mesmerising.

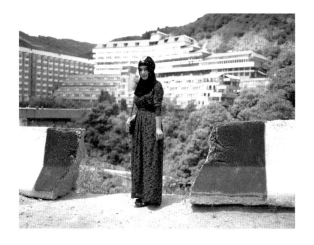

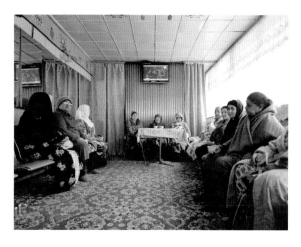

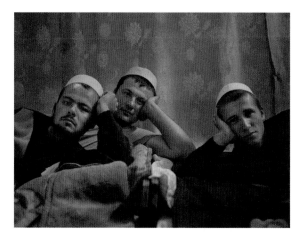

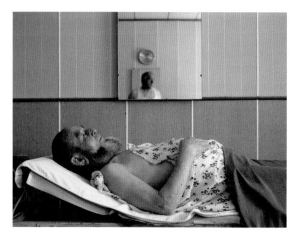

top: A Tajik woman in traditional clothing.
bottom: Men rest on outdoor beds in a café by the sanatorium.

top: Women drink herbal tea after a visit to the sauna.
bottom: A man recuperates after a visit to the steam room.

An abundance of potted plants line the entrance to the physiotherapy room.

Three times a day, guests descend several flights of stairs to reach the basement canteen of this cavernous building.

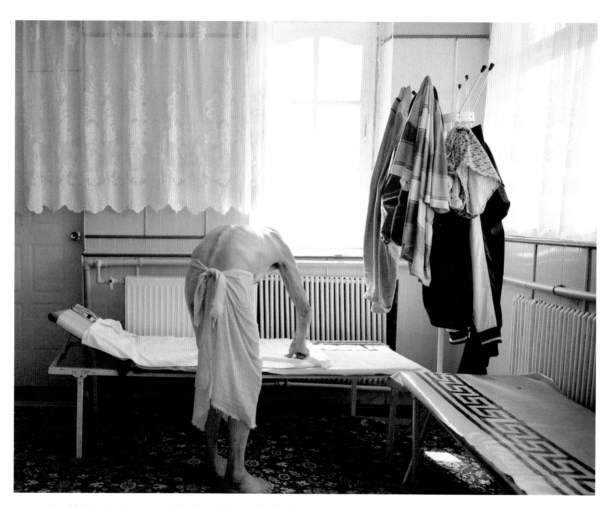

An elderly patient prepares to lie down after a session in the steam room.

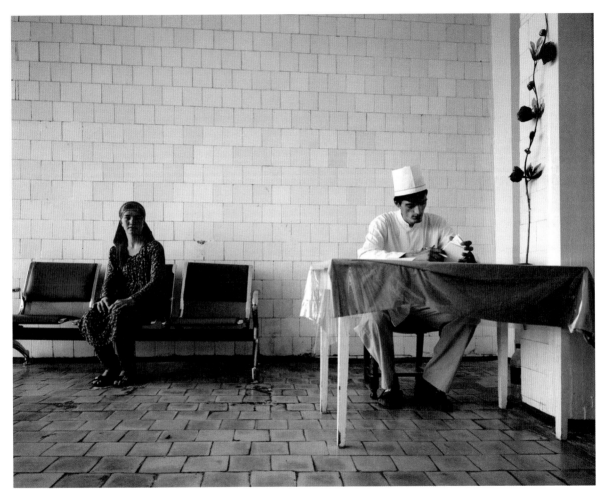

Sharaf Naziruf, a young doctor who grew up on the mountain, is one of the many locals to hail radon water as a panacea from God.

DNIEPER

Situated in the western Ukrainian city of Truskavets, in the foothills of the scenic Carpathian mountains, the accommodation block of the Dnieper sanatorium (built in 1977) resembles the stacked decks of a majestic ocean liner. Known as the 'green lungs of Europe', Truskavets is famed for its sulphur-scented, saline mineral water called *naftusia*. The town is home to 20 sanatoriums, as well as a number of other health centres, clinics and hospitals. The calcium-rich water is recommended for liver ailments, urinary infections and kidney stones, and can be drunk straight from the source at a public spring housed in a pavilion in the city centre.

Despite the sanatorium's good reputation, the number of tourists is half that of its 1980s peak, when nearly 500,000 guests would visit every year. Those in the industry blame the neglect of the region's facilities, claiming they are in desperate need of renovation.

right: With 290 rooms over eight floors, the sanatorium can house up to 500 guests.

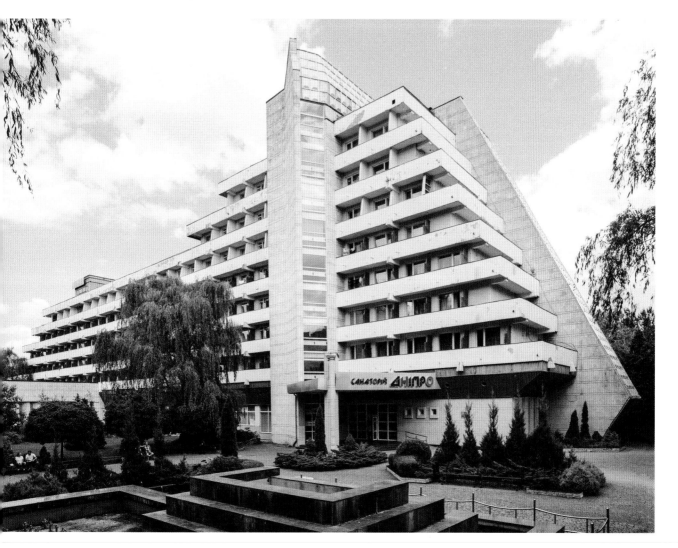

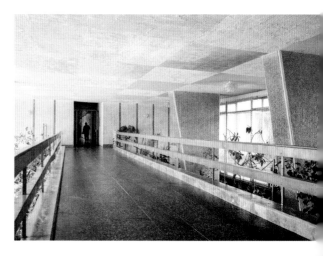

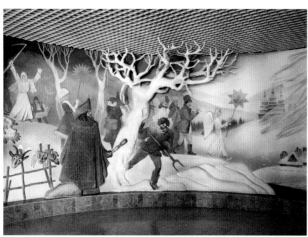

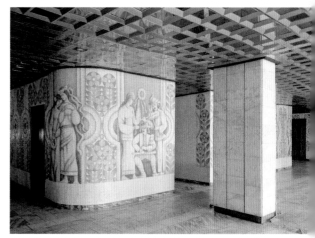

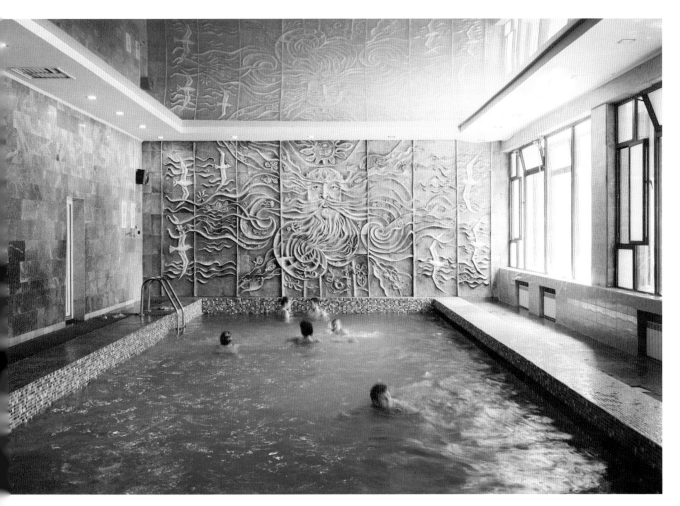

Above and left: Despite undergoing renovation in 2015, the sanatorium retains its Soviet character, with many of its interiors and murals depicting Ukrainian motifs still intact.

KUYALNIK

Mud is big business in Kuyalnik. For nearly 200 years, visitors have streamed to the sanatorium to take advantage of the area's sulphur-rich mud. A stroll along the nearby estuary, which was once connected to the Black Sea, reveals those with a DIY attitude wallowing in mud pools and smearing themselves with the black stuff. In the sanatorium itself, owned today by the Ukrainian Federation of Trade Unions, black-and-white photographs show before-and-after shots of wheelchair-bound men taking to their feet following a cure by the miraculous mud. 'In the Soviet era, 10,000 guests used to come here every day,' says sanatorium doctor Ekaterina Nikolaevna.

At the height of its popularity, the Kuyalnik compound spread over 106 hectares. The muddle of architectural styles, from neo-classicism to brutalism, tells the story of the piecemeal growth of the complex. It is still substantial today, containing three residential blocks, two treatment centres, a handful of restaurants and bars, a pool house, a grocery store and a cultural centre with disco and library. Only one of the main residential buildings – colossal high-rise towers erected in the 1980s, each accommodating 1,000 people – remains open to guests. The second has become a temporary refuge for around 470 internally displaced persons from the war in Donbass, while the third is used by an extreme sports company as a space for paintballing and rope-jumping.

The sanatorium offers countless treatments, involving various gadgets and gizmos. Ranging from Soviet-era to contemporary, these aim to combat almost any ailment, including weight loss, insomnia and many more. Despite this, mud continues to be the main draw. One guest, Vera Alexandrovna Tair, a 78-year-old blonde with taut skin and pencilled eyebrows, has been coming to Kuyalnik for more than 30 years. A former economist from Odessa, Tair attributes her youthful good looks to the mud, which she believes helps to soothe her joints and muscles. 'It's because of these baths that I'm young and pretty,' she says, lying in a tub of mud bubbling with carbon dioxide, sulphuric acid and salt water. 'A friend of mine who lives in the US says that although they have everything there, there's nothing like this mud.'

right: Thousands of people from across Ukraine travel to Kuyalnik each summer to undergo mud treatments in the sanatorium or bathe for free in the mud-filled estuary nearby.

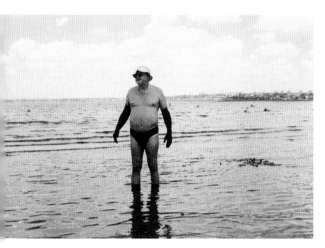
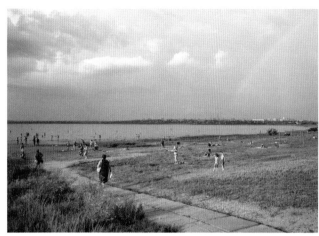

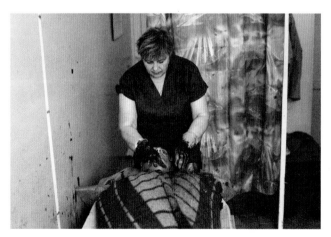

A couple walk back to the sanatorium after a visit to the estuary. Many fear that climate change is causing the water to dry up.

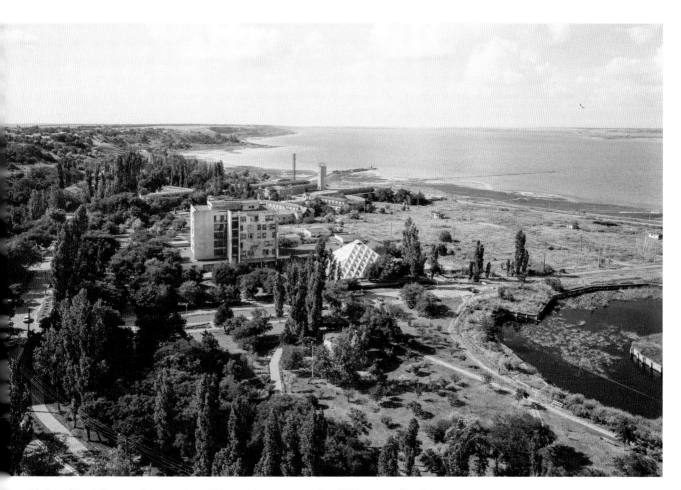

An aerial view of Kuyalnik sanatorium-complex, which sprawls across more than 100 hectares of land.

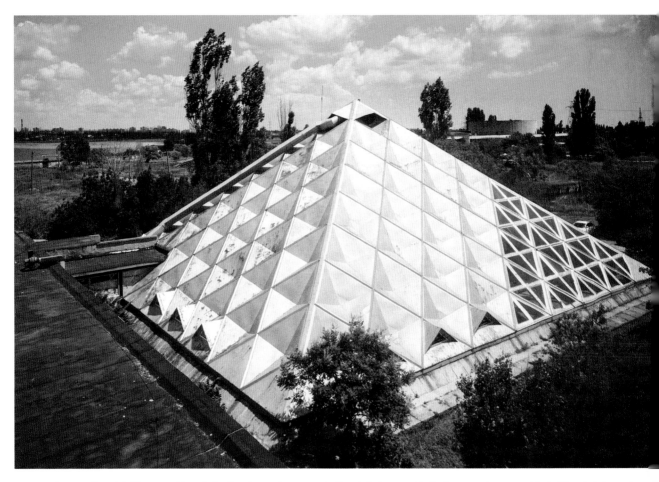

above and top left: The pyramid-roofed swimming pool.
top right: One of the four on-site restaurants.

bottom left: A concert hall where guests are provided with entertainment.
bottom right: A plant-filled corridor in the medical centre where guests can pause between treatments.

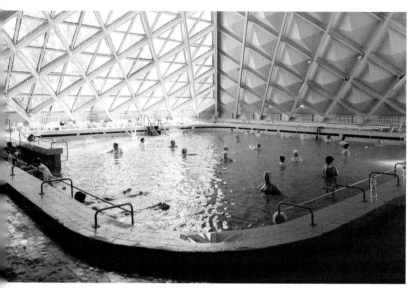
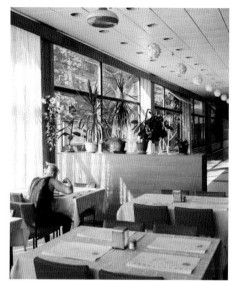

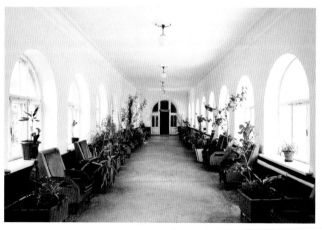

ODESSA

The history of the Odessa sanatorium is marked by intrigue. The striking Constructivist building designed by architect A. I. Dubinin was commissioned at the request of Felix Dzerzhinsky, the Polish aristocrat turned Bolshevik revolutionary who established the notorious Cheka, a forerunner of the KGB. However, 'Iron Felix' never lived to see the sanatorium, dying of a heart attack in 1926, two years before its completion. Located in the resort of Arcadia on the Black Sea coast, the area was first favoured by the tsars, then by the Soviet leaders and their workers. Today Arcadia is little more than a tacky beach resort, where luxury developments stand alongside a handful of fading sanatoriums and a shoreline dotted with nightclubs.

When the Odessa first opened, a monument to Stalin stood at the cylindrical entrance, between two incongruous-looking lions on plinths. The statue of Stalin was replaced by one of Dzerzhinsky in the 1950s under the instruction of Nikita Khrushchev, who initiated a process of de-Stalinisation across the Soviet Union. But the secret police chief ultimately met the same fate as his predecessor – his statue was taken down in 2015 in accordance with Ukraine's decommunisation law, which banned all symbols of communism. Today, a benign sculpture of an anonymous woman stands at the entrance. She is flanked by the lions, who have successfully outlasted two of the Soviet Union's most infamous figures.

Odessa, which was placed under the jurisdiction of the KGB in 1954 and is now overseen by the Security Service of Ukraine, has treated security and intelligence officers of all ranks since its inception. Today, their stays are either free or subsidised by the state. Fee-paying private guests are also welcome, although they tend to choose Odessa more for the sanatorium's location – a mere 500 metres from the beach – than for its treatments. The sanatorium specialises in rehabilitation for veterans, in particular those suffering from spinal injuries. According to director Dmitry Vladimirovich, the outbreak of violence in the country's far east has resulted in an increase in military patients, with a growing demand for psychotherapy to treat post-traumatic stress.

right: Once a Constructivist icon, the Odessa's exterior has fallen into relative disrepair, with insufficient government funds for maintenance. Arcadia Beach (top left) attracts guests from the nearby Odessa sanatorium.

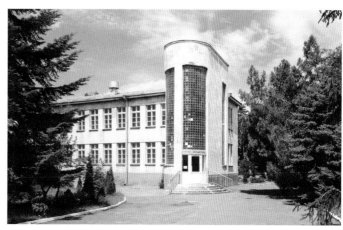
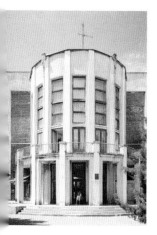

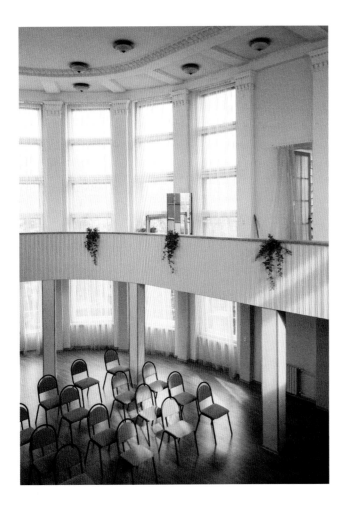

In its glory days, the Odessa sanatorium boasted 48 hectares of land and a lush botanical garden. While the garden still exists, sprinkled with a range of conifers, its grounds have shrunk to just 14 hectares, a change that reflects the broader decline in sanatorium culture. The building itself has also seen better days. Vladimirovich laments the paucity of funds for its upkeep and the inefficient old heating system, which makes it too expensive to host guests in winter. 'When we were part of the Soviet Union, these sanatoriums were used year round.'

left: One of the sanatorium's many halls, where guests can listen to recitals and lectures.

opposite, clockwise from top left: Two young ballet students practise before a performance at the on-site cultural centre, offered as a free space for locals to use.
A man soaks in a mineral-water bath.
A medical attendant prepares the plastic for the mud-wrap treatment.
Once a patient has been covered with warm mud, they are then wrapped in plastic to ensure optimum heat retention.

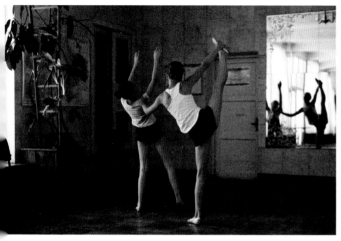
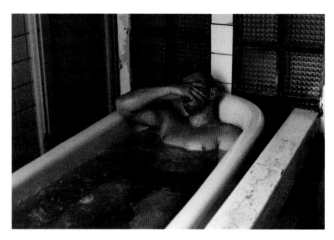
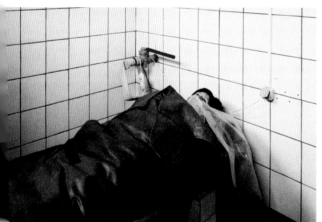
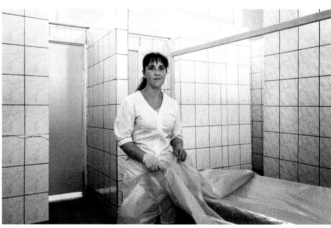

A local dance troupe poses before a performance.

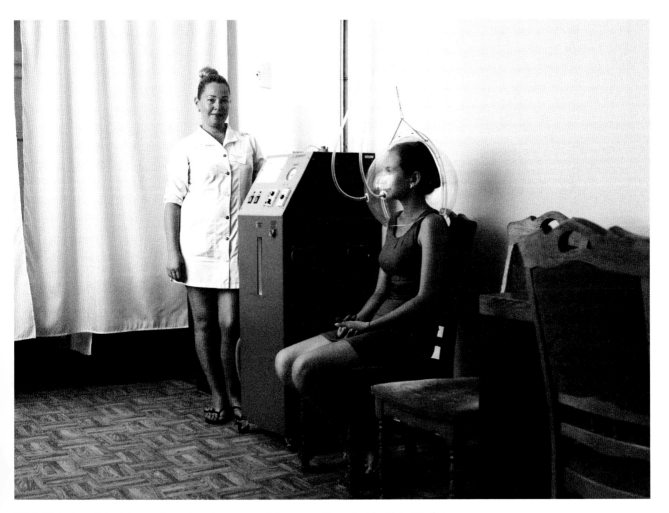

This bubble-shaped simulator produces clean, low-oxygen air to prepare the patient for high altitudes.

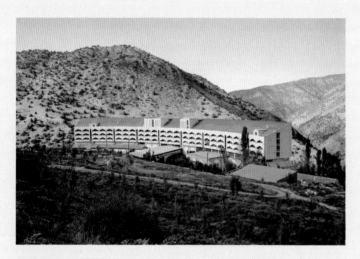

The sanatorium sits on the northern slopes of the Turkestan mountain range, in the Jizzakh Region of the country, close to the border with Tajikistan. The Zaamin National Park contains the largest and oldest forest of juniper trees in the world.

ZAAMIN

Located in the picturesque Zaamin National Park, 2,000 metres above sea level, the sanatorium opened in 1988, its construction financed by trade unions from each of the Soviet republics. From above, it is striking: a white, curved building, backed by juniper-covered mountains, in a landscape roamed by wild horses and dotted with ruins of centuries-old castles.

As well as treating respiratory diseases, the sanatorium boasts a salt room that uses crystals flown in from Ukraine. However, its particular specialities are homemade remedies based on the discoveries of 10th-century Persian physician Avicenna, whose recipes use locally grown herbs such as buckthorn, hawthorn, ziziphora and rose hips. Containing over 50 types of medicinal plants and flowers, the national park is considered a natural health resort by locals. It is also home to animals including wolves, eagles and even the elusive snow leopard.

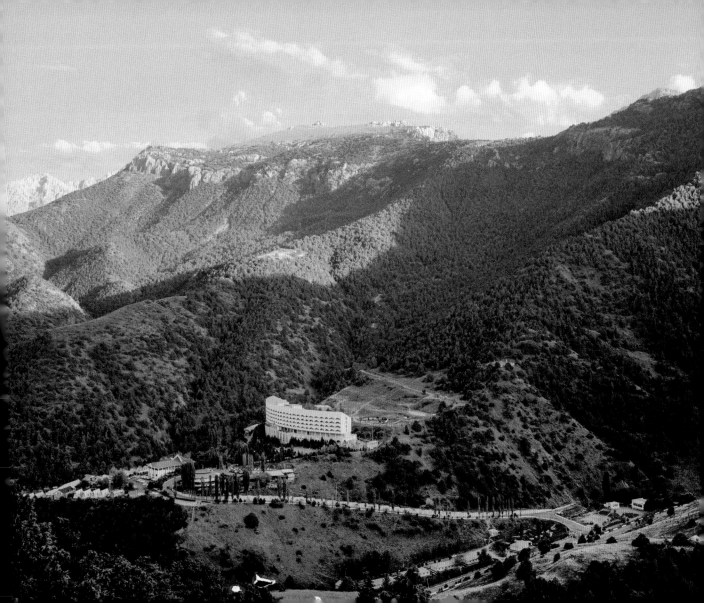

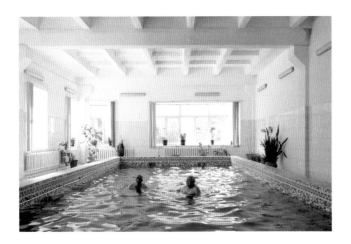

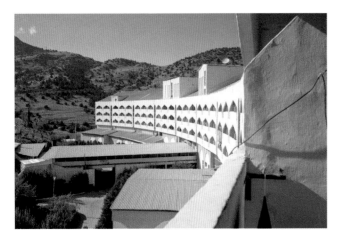

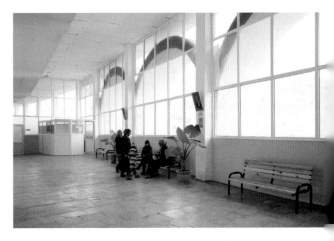

top: Facilities include water therapy and inhalation equipment used to ease the symptoms of various respiratory diseases.

bottom: The balcony and large arched windows offer guests a picturesque view across the national park and the Turkestan Range.

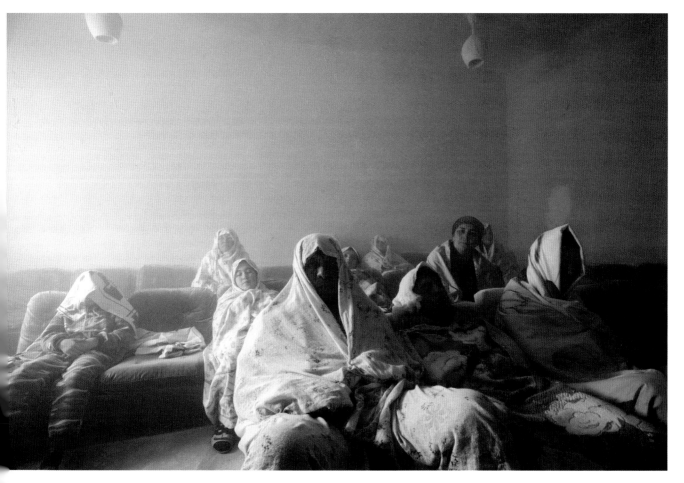

In the halotherapy (salt treatment) room, guests use towels and blankets to prevent hair and clothing from being covered by a fine layer of salt.

What are the most important considerations when designing a sanatorium?

It all started with a post-war government order. The national economy had to be restored, so housing had to be provided for workers. A campaign against architectural extravagances was announced. Now everything had to be standardised – and this applied to recreational buildings as well.

I worked as head architect for Kurortproekt [The Institute for Resorts] for more than 30 years. I launched the main programme in resort building. Importantly, we had to keep in mind the relationship between the architectural object and the environment. Although it might seem strange, the natural environment comes first and the architectural object second.

There are two ways in which this can be approached. Either the object conforms to the natural environment, or the object is contrasted with nature. If the object is large, it can be made more compact, as with Druzhba, which has three pillars and appears to be hovering. In this case the object has been contrasted with nature for the sake of the latter's preservation, as we were protecting everything beneath the object. What's very important – the essence of all my work – is the attempt to personalise the object, to create the impression that it was built for you alone. The second point is that each functional zone must be designed optimally – so that,

for example, the view from each bedroom consists only of natural landscape.

How was the location for Druzhba chosen and what challenges did you face during the project?

The initiative came from Czechoslovakia. The government there wanted to build a sanatorium for both Soviet and Czechoslovakian workers. They chose the location in Crimea because they had some nostalgic, romantic feelings for the region from their youth. However, the area was already developed and there was just this slope left. It was impossible to create a regular building there in case of landslides. Moreover there was a fracture in the land beneath it. So many challenges! We came to the conclusion that a circular object would be the optimal shape. When the project was ready, we had to present it for approval to our trade union management, to Ivan Kozlov. We didn't know what to expect or how he'd react. He looked at it and said, 'A ring! A symbol of friendship between two nations. A simple shape. I like it. Go ahead!'

What comes first for you: function or aesthetics?

While everything must function perfectly, the main objective of a building is still to have an emotional, aesthetic impact. When you move across the building,

you pass the atrium. You breathe in. You stop. You move on. Many such moments exist in Druzhba.

The most important idea is that most of the building's elements transfer their load through a cantilever system that makes it look as if everything is hovering and gives the building a sci-fi look. A lot of new technologies were incorporated – like heating pumps that use warmth from the sea to heat, ventilate and air-condition the building. These were all experimental technologies at that time.

The emotional impact of the building was really important for me. In the foyer there's a triangular fountain that was designed as a light show as well. You could see the sea from certain spots and when a wave broke, it felt as if you were on a ship, as if you were moving. Unfortunately this [light] was never made.

As a Soviet architect did you have to implement ideological ideas in your work? If so, how did you manage to do it?

Ideologically speaking, during Soviet times we started out at pioneer camps. Aged eighteen, you entered the army [conscripted for at least two years] and after that, everybody was made to serve the state. In that context, recreational buildings were designed with 200, 250, 500 or even 1,000 rooms. These armada-like buildings directly represented an ideology. But there was a tension from my very first project: I wanted to place the individual

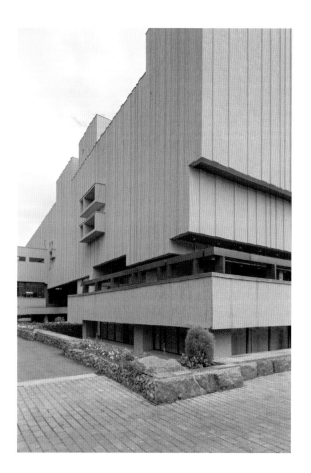

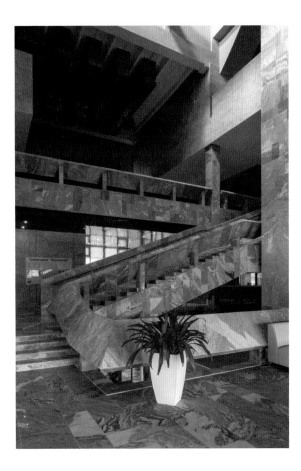

The large atrium, complete with marble staircase and balustrade.

first, not the collective system.

My other building, Voronovo [in the Moscow region], which was chosen as one of the best examples of Soviet modernism, is exactly what I'm talking about. The section that houses the bedrooms is hidden from guests when they arrive. It has 600 rooms but we managed to obscure this by dividing it into zones.

Is Voronovo still working?

Yes, but now it's owned by the Ministry of Economic Development and they have completely renovated it. I was scared to go there at first because some of the changes they had made were unacceptable. The building was originally made from travertine [a type of limestone], but this was refaced with stucco and there are already cracks appearing.

Have you ever stayed at the sanatorium?

Yes, because I'm interested in the result. I like talking to people who stay in a place I've designed, because I designed it for them. In Druzhba I got to know a couple who first visited when it opened in 1985. They've never been anywhere else since. Every year they go to Druzhba. They asked me how old I was when I was entrusted with such an immense project – I was 50.

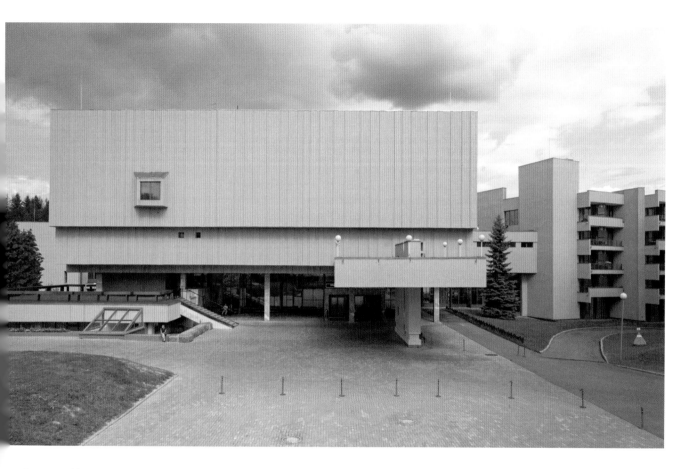

Constructed between 1968 and 1974, the Voronovo sanatorium was reserved for official use by Gosplan, the State Planning Committee, responsible for economic planning in the USSR.

PHOTOGRAPHY

Claudine Doury: 27-33, 65-77
René Fietzek: 19-25, 79-81, 90-95
Olya Ivanova: 99-115
Natalia Kupriyanova: 120-121, 189-191
Dmitry Lookianov: 15-17, 116-119, 122-131, 139-149
Egor Rogalev: 34-45, 132-137, 150-159, 169-187
Vladimir Shipotilnikov: 5, 10-11
Michal Solarski: 47-63, 81-89, 96-97, 161-167

The author would like to thank the following people for their research and assistance in making this project possible: Lesya Myata, Alyona Kudryavtseva and Kateryna Shcherbakova.

Published in 2017

FUEL Design & Publishing
33 Fournier Street
London E1 6QE

fuel-design.com

Photographs © Claudine Doury, René Fietzek, Olya Ivanova, Natalia Kupriyanova, Dmitry Lookianov, Egor Rogalev, Vladimir Shipotilnikov, Michal Solarski
Text © Maryam Omidi
Designed and edited by Murray & Sorrell FUEL

All rights reserved.
No part of this book may be reproduced without the written permission of the publisher.

Distribution by Thames & Hudson / D. A. P.
ISBN: 978-0-9931911-9-0